Snippets of
NEW ORLEANS

ISBN: 978-1-935754-99-2

http://ulpress.org

University of Louisiana at Lafayette Press
P.O. Box 40831
Lafayette, LA 70504-0831

Snippets of NEW ORLEANS

TEXT & ILLUSTRATION BY EMMA FICK

2017

UNIVERSITY OF LOUISIANA AT LAFAYETTE PRESS

A NOT-TO-SCALE, NON-COMPREHENSIVE, GEOGRAPHICALLY-APPROXIMATE
MAP OF NEW ORLEANS

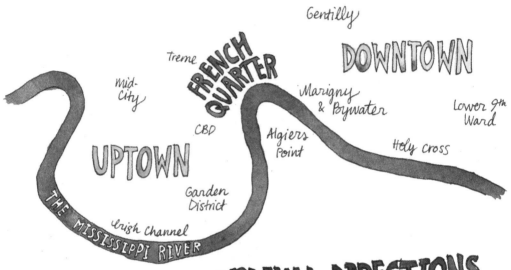

Gentilly

Treme

FRENCH QUARTER

DOWNTOWN

Mid-City

Marigny & Bywater

Lower 9th Ward

CBD

Algiers Point

Holy Cross

UPTOWN

Garden District

THE MISSISSIPPI RIVER

Irish Channel

CARDINAL DIRECTIONS, NEW ORLEANS:

CARDINAL DIRECTIONS, EVERYWHERE ELSE:

North

West ← → East

South

Lakeside

Upriver/ Uptown ← → Downriver/ Downtown

Riverside

CONTENTS

INTRODUCTION

Snippets are fragments of things. They are people observed, foods consumed, ornaments spotted: a man on a streetcar, crawfish shells on the sidewalk, an ornate cornstalk-shaped fence.

I began the "Snippets" project in Serbia, where I lived for two years after graduating from college. It was there I honed in on the exact manner in which I wanted to communicate culture: in a mish-mash of micro and macro, scouring art history books about ancient emperors and observing a woman with eccentric hair talk animatedly at a café, recording both in my notebooks with equal zeal. I became confident that these two people—the emperor of the past and the eccentric-haired woman of the present—embodied equal cultural significance, and that to immerse oneself in a place means to try and hold all its elements, past and present, grandiose and mundane, in a single plane of vision.

This is, of course, impossible. The result is fragments, vignettes. In Jackson Square, for example: a vision of the first French settlers coming up the Mississippi alongside the sight of a garishly painted street performer harassing passers-by. If we cannot hold all facets of a place in our mind at once, I think the next best thing is to honor our fragmented understanding, to see in "Snippets."

The nature of my work—as an artist and a writer—is to be an observer, to exist in the margins; to go through life feeling as if I'm peering into a window, always trying to frame things. In Serbia, when I was setting out on this path as artist/illustrator, my feelings as an outsider felt tied up in my identity as a foreigner. My lack of understanding fit cleanly into that role. I delighted in asking questions and filling in the gaps. In fact, it took returning to Louisiana, where I was born and raised, to realize I didn't feel like an outsider in Serbia because it was a foreign country. I felt that way because to observe and record culture means, in certain essential ways, *always* to be outside of it.

6

It was right after I published *Snippets of Serbia* that I returned to the US and began work on a second book, this time about the place where I grew up. I thought it would be easier, faster. After all, I'd gone to Serbia with little-to-no understanding of the culture and had had to learn everything from the ground up. *In New Orleans,* I thought, *it will be easier. I have a head start! I already know so much!*

I was wrong. It was not easier, or faster. I did not know so much.

I learned and re-learned a lot of things making this book. I learned that even in my "home" in Louisiana I feel I am an outsider peering into a window. I re-learned how beautiful and bizarre New Orleans is, how every street has a distinct personality. I learned that being a foreigner in Serbia had actually made it easier to ask questions; that the delight I'd felt asking questions in Serbia turned to trepidation in New Orleans. I re-learned that I know very little about anything, and that the more I learn the more I realize how little I know. I learned that asking for entry into people's personal lives is complicated and requires a lot of mental and ethical somersaults.

This book is my most earnest and honest reflection of New Orleans: triumphant and tragic, gaudy and gritty, elegant and ugly, rich and poor, a city that embodies all these and other polar opposites with a perverse kind of grace. My account is flawed and incomplete in the way all our experiences are flawed and incomplete: there are always vistas left to see, flavors left to try, stories left to hear; there are assumptions made, words misunderstood, histories distorted.

May these pages communicate the New Orleans I know, and may you weave your own New Orleans truth between the pages.

emma fick

ESSENTIALS

8

New Orleans is nestled —
strategically, improbably —
into this sharp bend in
the Mississippi
River

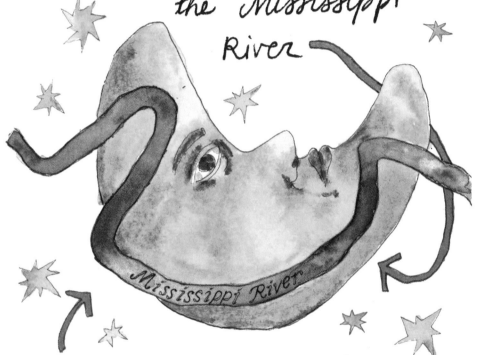

Mississippi River

that's why it's called
THE CRESCENT CITY

ESSENTIAL New Orleans BRANDS

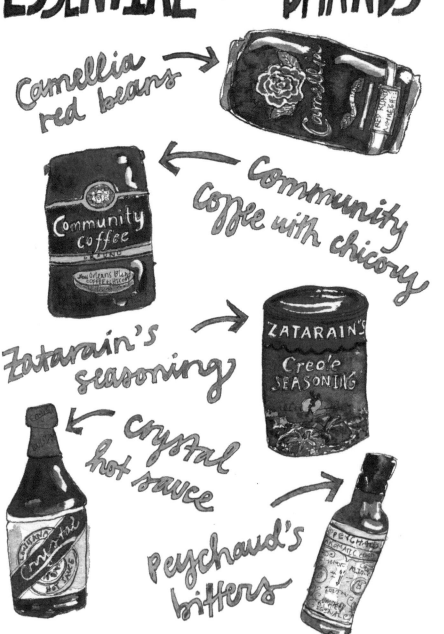

Camellia red beans

Community coffee with chicory

Zatarain's seasoning

Crystal hot sauce

Peychaud's bitters

HOW TO (mis) PRONOUNCE street names ACCURATELY

[nope, doesn't matter if you speak French/
Greek/Choctaw/whatever — you'll still be wrong]

Tchoupitoulas ← chop-uh-TOO-luhs

CHAR- → truhs Chartres

Calliope ← KA-lee-ope

a lot of folks call it → SEE-EL-TEN (like C-L-10) Clio

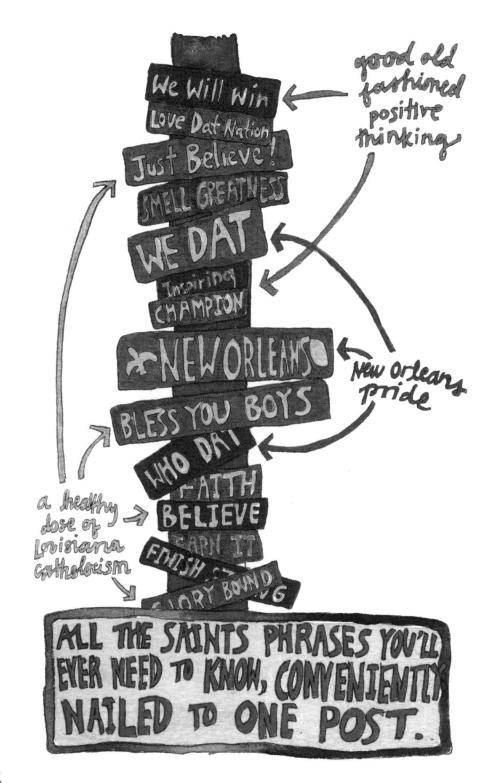

Second Lines

THE "FIRST" OR "MAIN LINE" IS THE OFFICIAL, SANCTIONED PROCESSION— WHETHER A BRASS BAND WITH A JAZZ FUNERAL OR A SOCIAL AID & PLEASURE CLUB — AND THE PEOPLE THAT FOLLOW BEHIND DANCING, STRUTTING, & DRINKING MAKE UP THE "SECOND LINE."

a sunday tradition

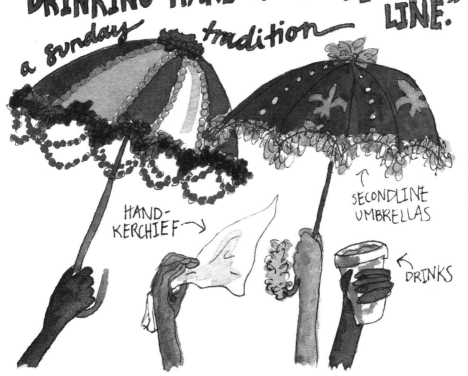

HAND-KERCHIEF →

← SECONDLINE UMBRELLAS

← DRINKS

A New Orleanian's social calendar: AN IMPRECISE PIE CHART

% OF LEISURE TIME, PER YEAR, SPENT:

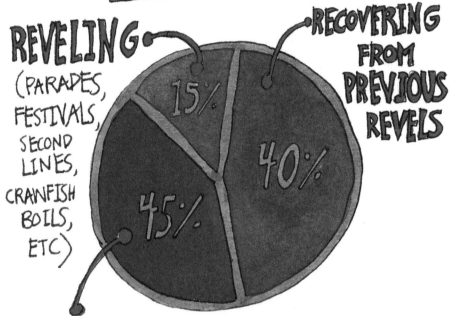

REVELING (PARADES, FESTIVALS, SECOND LINES, CRAWFISH BOILS, ETC) — 15%

RECOVERING FROM PREVIOUS REVELS — 40%

PREPARING FOR UPCOMING REVELS (COSTUME-MAKING, BAR-STOCKING LOGISTICS-ARRANGING) — 45%

a vicious cycle.

THE COSTUME CLOSET

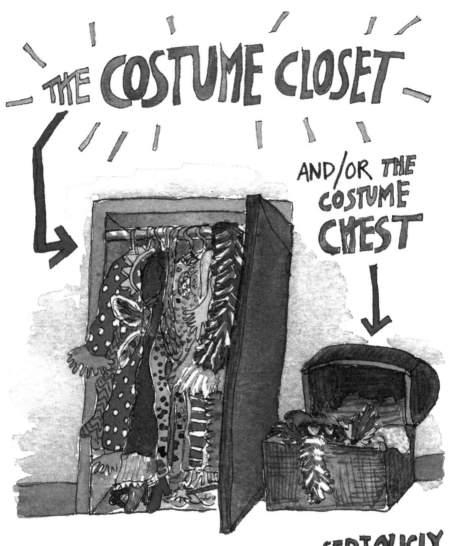

AND/OR THE COSTUME CHEST

costumery is taken so **SERIOUSLY** and required so **OFTEN** that nearly everyone has a designated space for all their fanciful garb so as to never be in a bind.

festivals abound

IN NEW ORLEANS. IT'S A *habit,* a *compulsion,* TO CELEBRATE.

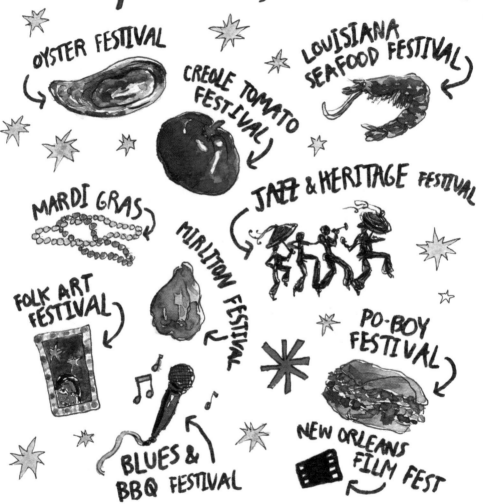

OYSTER FESTIVAL

CREOLE TOMATO FESTIVAL

LOUISIANA SEAFOOD FESTIVAL

MARDI GRAS

JAZZ & HERITAGE FESTIVAL

MIRLITON FESTIVAL

FOLK ART FESTIVAL

PO-BOY FESTIVAL

BLUES & BBQ FESTIVAL

NEW ORLEANS FILM FEST

※ TO NAME JUST A FEW. THIS IS A **VERY ABBREVIATED** LIST.

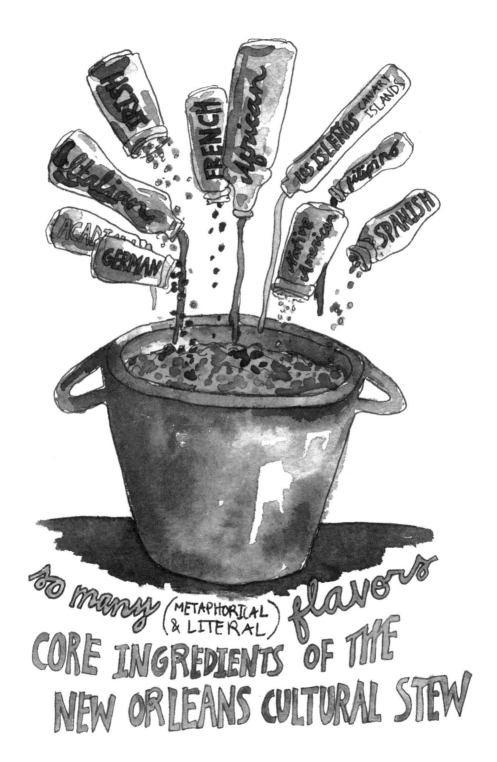

so many (METAPHORICAL & LITERAL) flavors
CORE INGREDIENTS OF THE
NEW ORLEANS CULTURAL STEW

STREETCARS

THE ST CHARLES LINE IS THE OLDEST; IT'S BEEN IN OPERATION SINCE 1835

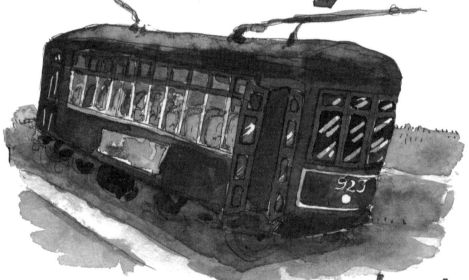

not the most efficient mode of transportation, but certainly a picturesque one.

STREETCAR, interior:

the insides of the St Charles line cars look exactly as they did in the 1920s.

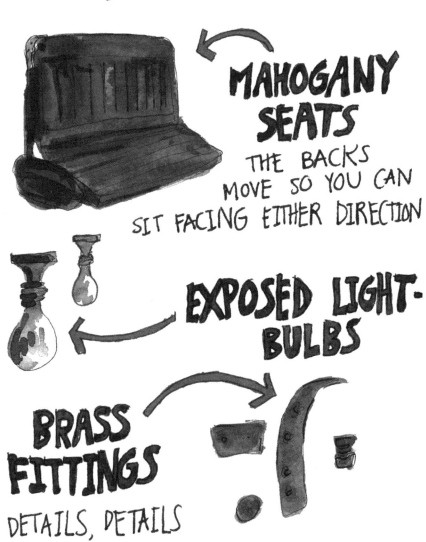

MAHOGANY SEATS

THE BACKS MOVE SO YOU CAN SIT FACING EITHER DIRECTION

EXPOSED LIGHT-BULBS

BRASS FITTINGS

DETAILS, DETAILS

SOME USEFUL EXPRESSIONS:

lagniappe — A SMALL SOME-THING EXTRA, A FREE GIFT WITH PURCHASE. etymologically, comes from the spanish/French creoles — derived from the Quechua word "YAPA," or "gift."

describes the RELAXED way of life in New Orleans → *laissez-faire*

"LET THE GOOD TIMES ROLL!" self-explanatory. *laissez les bon temps rouler!* (can also be a statement — question mark optional.) → *who dat?* A show of support for the New Orleans Saints football team. Short for "WHO DAT SAY DEY GONNA BEAT DEM SAINTS?"

ON THE SIDEWALK, MONDAY MORNING DURING CRAWFISH SEASON:

weekend evidence.

corner stores

ARCHITECTURALLY, THEY'RE EASY TO SPOT: SIMPLY LOOK FOR A **BEVELED ENTRANCE** AND DOORWAY FACING AN INTERSECTION

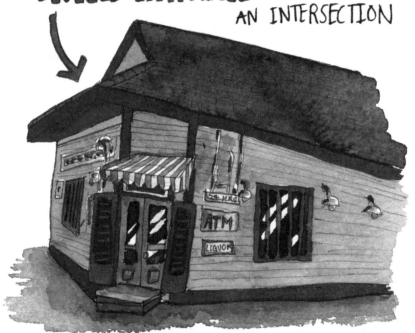

CORNER STORES USED TO BE SOCIAL & ECONOMIC PILLARS IN RESIDENTIAL COMMUNITIES

[THEIR PEAK YEARS: 1870-1929. SERIOUS DECLINE BEGAN IN THE 1980s]

THEY'RE DISAPPEARING: CLOSING, FALLING INTO DISREPAIR, BEING CONVERTED INTO PRIVATE RESIDENCES. *shame.*

DR BOB'S →
SIGNS — "Be Nice or Leave" IS THE MOST FAMOUS

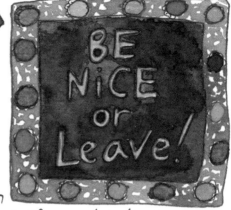

bottle cap borders

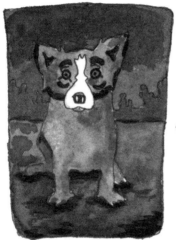

← **THE BLUE DOG**
BY GEORGE RODRIGUE

SIMON'S →
SLOGAN SIGNS. content spans everything from hot dogs to inspirational quotes.

FAMILIAR WORKS OF ART IN NEW ORLEANS POPULAR CULTURE

LOOK DOWN — *culture underfoot.*

the great big oak tree roots push up through the sidewalk (watch your step!)

embedded blue-lettered tiles relay street names (a New Orleans convention since the late 19th century)

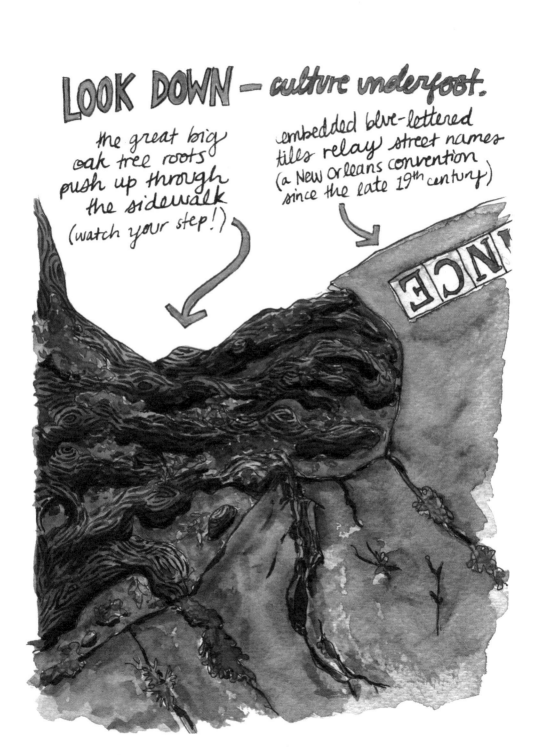

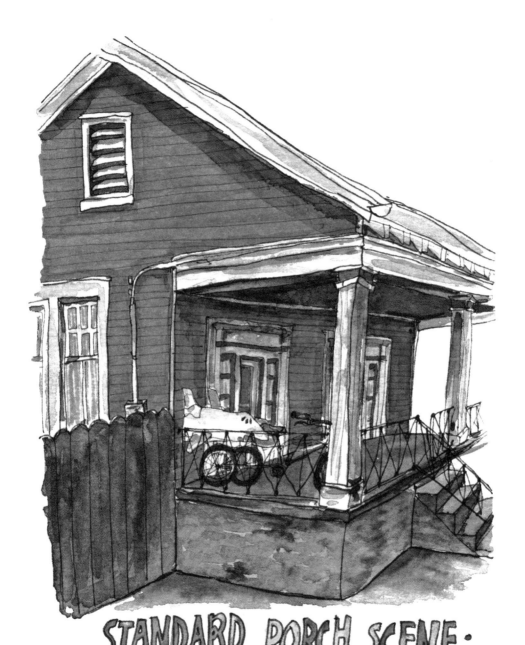

STANDARD PORCH SCENE:

casually featuring some oddity either
directly or tangentially carnival-related

cemetery symbols

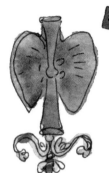

← **THE HOURGLASS WITH WINGS**
literally, "TIME FLIES";
death comes too soon.

THE INVERTED TORCH
symbol of loss and
mourning. an inverted
flame is soon extinguished.

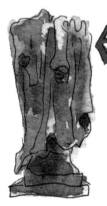

← **THE CLOAK-DRAPED URN**
the cloak represents
the earthly body left
behind when the soul
goes to heaven.

NEW ORLEANS CEMETERY LOGISTICS

CATHOLICS CAN'T BE CREMATED, BUT THE CITY'S HIGH WATER TABLE MAKES BURIAL COMPLICATED. **SOLUTION: ABOVE-GROUND TOMBS.**

WALL VAULTS ARE USUALLY TEMPORARY STORAGE: CATHOLOCISM STIPULATES A PERSON BE **BURIED ALONE FOR 1 YEAR** (PURGATORY, ETC) SO IF **ANOTHER FAMILY MEMBER DIES WITHIN THAT YEAR THEY'RE PLACED IN A WALL VAULT** UNTIL THE YEAR PASSES & THEY CAN JOIN THE FAMILY CRYPT.

[ALSO: the sun's heat on the stone tombs acts as an incinerator, so the body slowly cremates over the course of the year & there's room for the next family member, ad infinitum. ingenious system, no?]

27

A SHORT DICTIONARY
OF RELEVANT LAND FORMS

THE NEUTRAL GROUND

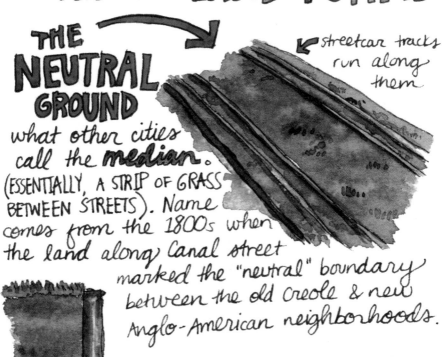

streetcar tracks run along them

what other cities call the *median*. (ESSENTIALLY, A STRIP OF GRASS BETWEEN STREETS). Name comes from the 1800s when the land along Canal street marked the "neutral" boundary between the old Creole & new Anglo-American neighborhoods.

LEVEE

AN EMBANKMENT THAT PREVENTS THE RIVER FROM OVERFLOWING. THOUGH THERE WERE ALWAYS NATURAL LEVEES ALONG THE MISSISSIPPI, NEW ORLEANS HAS SUPPLEMENTED THEM WITH MAN-MADE VERSIONS SINCE 1722

BATTURE, the land between the levee & the river

THE HIGHER THE GROUND, THE HIGHER THE SOCIO-ECONOMIC STATUS:

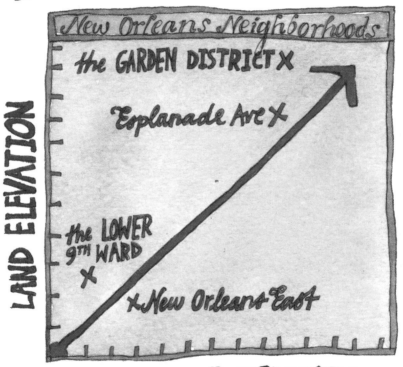

New Orleans Neighborhoods

LAND ELEVATION

the GARDEN DISTRICT X

Esplanade Ave X

the LOWER 9TH WARD X

X New Orleans East

WEALTH OF RESIDENTS

general rule of thumb, but plenty of exceptions. In the past, it was different: the high ground by the river was where industrial laborers & shipyard workers lived.

GONE, BUT NOT FORGOTTEN:
(far from it: NOSTALGIA IS A FAVORITE NEW ORLEANS PASTIME)

Schwegmann
SUPER MARKETS

THE STORE HAD ITS OWN BRAND OF CHEAP BEER & LIQUOR.
THEY ARE REMEMBERED FONDLY.

folks remember sitting at the soda fountain counters as kids

K&B DRUGSTORES

← McKENZIE'S BEGAN THE KING CAKE BABY TREND

McKENZIE'S BAKERY

THEIR KING CAKE IS THE GOLDEN STANDARD: A SIMPLE BRIOCHE, NO FILLING, TOPPED WITH COLORED SUGAR. NOW YOU CAN FIND THIS CAKE AT TASTEE DONUTS, WHO BOUGHT THE RECIPE.

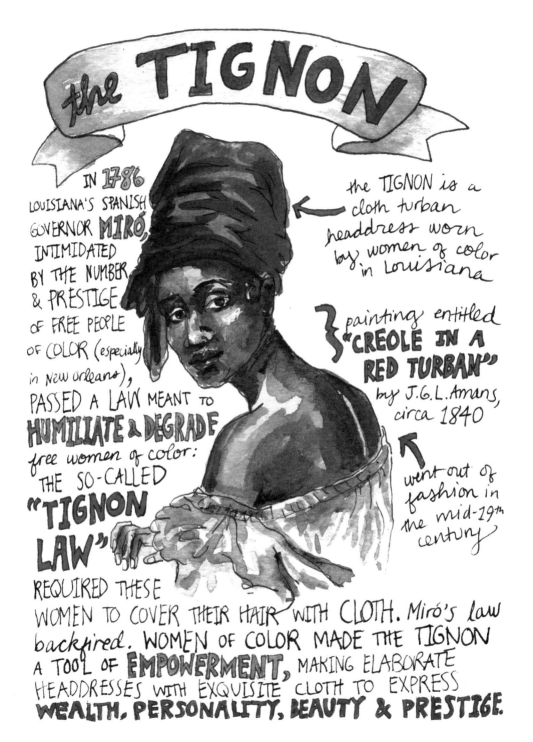

the TIGNON

IN **1786** LOUISIANA'S SPANISH GOVERNOR **MIRÓ**, INTIMIDATED BY THE NUMBER & PRESTIGE OF FREE PEOPLE OF COLOR (especially in New Orleans), PASSED A LAW MEANT TO **HUMILIATE & DEGRADE** free women of color: THE SO-CALLED **"TIGNON LAW"** REQUIRED THESE WOMEN TO COVER THEIR HAIR WITH CLOTH. Miró's law backfired. WOMEN OF COLOR MADE THE TIGNON A TOOL OF **EMPOWERMENT**, MAKING ELABORATE HEADDRESSES WITH EXQUISITE CLOTH TO EXPRESS **WEALTH, PERSONALITY, BEAUTY & PRESTIGE.**

the TIGNON is a cloth turban headdress worn by women of color in Louisiana

painting entitled **"CREOLE IN A RED TURBAN"** by J.G.L. Amans, circa 1840

went out of fashion in the mid-19th century

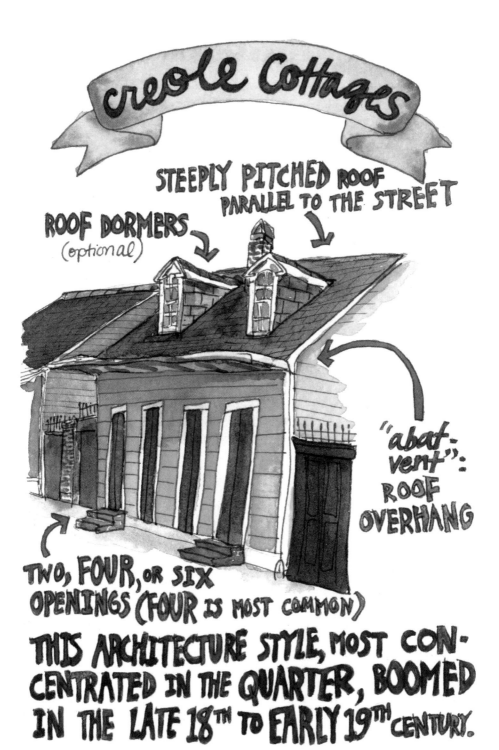

creole Cottages

STEEPLY PITCHED ROOF PARALLEL TO THE STREET

ROOF DORMERS (optional)

"abat-vent": ROOF OVERHANG

TWO, FOUR, OR SIX OPENINGS (FOUR IS MOST COMMON)

THIS ARCHITECTURE STYLE, MOST CON-CENTRATED IN THE QUARTER, BOOMED IN THE LATE 18TH TO EARLY 19TH CENTURY.

IN NEW ORLEANS, CHEFS ARE CELEBRITIES. THIS IS THE ONE WHO STARTED IT ALL

Chef Paul Prudhomme

hot sauce

LOUISIANA

HOT SAUCE

the real deal!

on EVERYTHING.

MOST EXUBERANT

FENCES.

FOOD

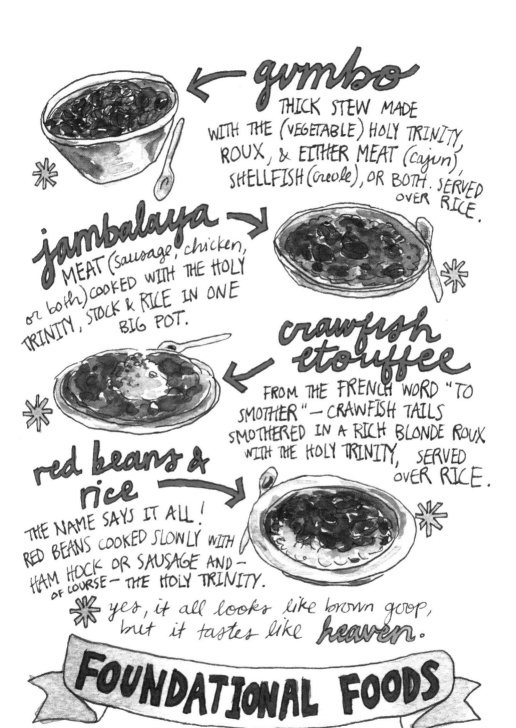

gumbo

THICK STEW MADE WITH THE (VEGETABLE) HOLY TRINITY, ROUX, & EITHER MEAT (cajun), SHELLFISH (creole), OR BOTH. SERVED OVER RICE.

jambalaya

MEAT (sausage, chicken, or both) COOKED WITH THE HOLY TRINITY, STOCK & RICE IN ONE BIG POT.

crawfish etouffee

FROM THE FRENCH WORD "TO SMOTHER" — CRAWFISH TAILS SMOTHERED IN A RICH BLONDE ROUX WITH THE HOLY TRINITY, SERVED OVER RICE.

red beans & rice

THE NAME SAYS IT ALL! RED BEANS COOKED SLOWLY WITH HAM HOCK OR SAUSAGE AND — OF COURSE — THE HOLY TRINITY.

✳ yes, it all looks like brown goop, but it tastes like *heaven*.

FOUNDATIONAL FOODS

37

THE HOLY TRINITY
of Cajun & Creole cooking

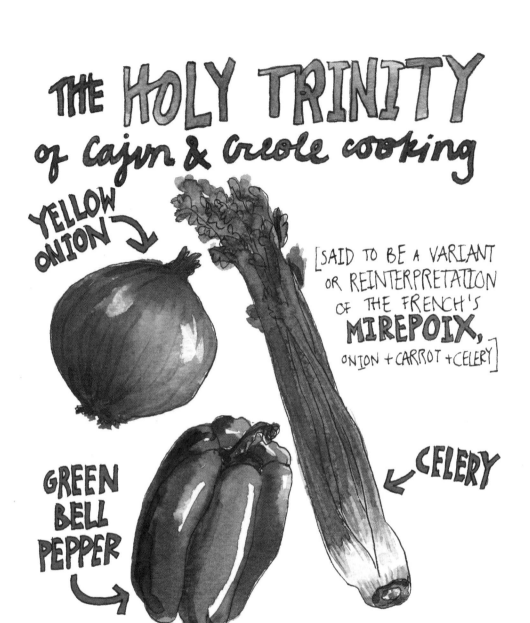

YELLOW ONION

[SAID TO BE A VARIANT OR REINTERPRETATION OF THE FRENCH'S **MIREPOIX,** ONION + CARROT + CELERY]

CELERY

GREEN BELL PEPPER

chopped fine & cooked in oil, these humble veggies form a complex, bold flavor — the base of New Orleans cooking.

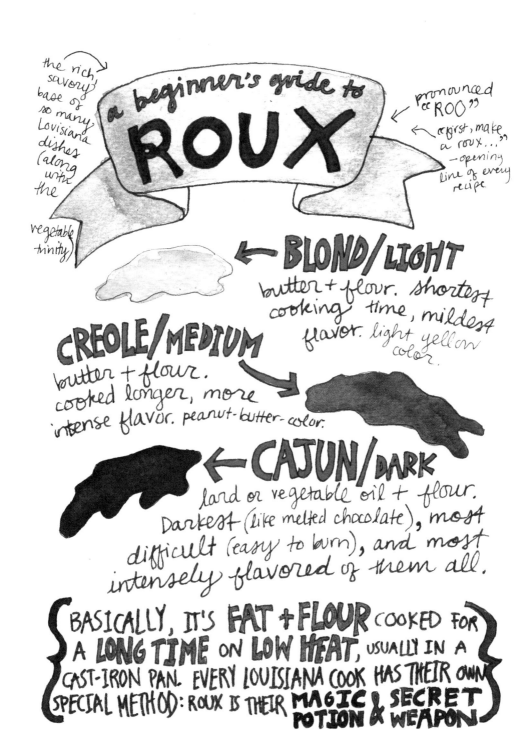

the rich savory base of so many Louisiana dishes (along with the vegetable trinity)

a beginner's guide to ROUX

pronounced "ROO"

"first, make a roux..." — opening line of every recipe

← BLOND/LIGHT
butter + flour. shortest cooking time, mildest flavor. light yellow color.

CREOLE/MEDIUM
butter + flour. cooked longer, more intense flavor. peanut-butter-color.

← CAJUN/DARK
lard or vegetable oil + flour. Darkest (like melted chocolate), most difficult (easy to burn), and most intensely flavored of them all.

{ BASICALLY, IT'S **FAT + FLOUR** COOKED FOR A **LONG TIME** ON **LOW HEAT**, USUALLY IN A CAST-IRON PAN. EVERY LOUISIANA COOK HAS THEIR OWN SPECIAL METHOD: ROUX IS THEIR **MAGIC POTION** & **SECRET WEAPON** }

LEIDENHEIMER

BAKERS OF
THE CLASSIC POBOY LOAF

← crackly exterior

soft, fluffy interior

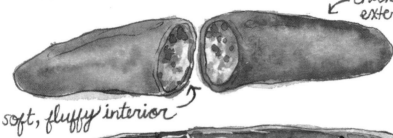

GOOD TO THE LAST CRUMB

LEIDENHEIMER BAKING CO

ZIP

TWIN

Poboy Loaf

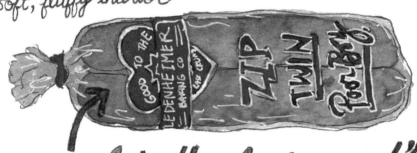

"good to the last crumb"

GEORGE LEIDENHEIMER CAME TO NEW ORLEANS IN 1896 & QUICKLY STARTED BAKING THE CITY'S STAPLE: *FRENCH BREAD.* TODAY, LEIDENHEIMER BAKING CO. IS A **REVERED** PRODUCER OF THE LOAF SO ESSENTIAL TO POBOYS.

MUCH AS I LOVE THE SALTY-GOODNESS OF MUFFALETTAS,

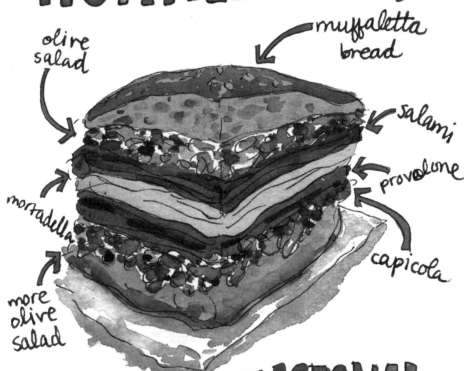

olive salad

muffaletta bread

salami

provolone

mortadella

capicola

more olive salad

THEY'RE AN OCCASIONAL INDULGENCE — THEY'LL LEAVE YOU THIRSTY FOR AGES.

mirliton mania

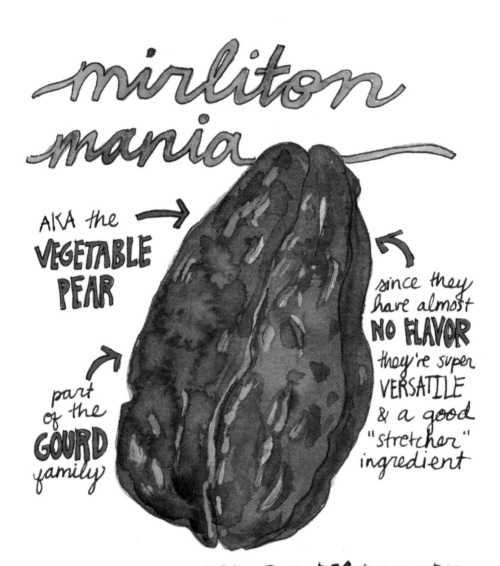

AKA the **VEGETABLE PEAR**

since they have almost **NO FLAVOR** they're super **VERSATILE** & a good "stretcher" ingredient

part of the **GOURD** family

THESE WRINKLED, LUMPY, LOVABLE LITTLE VEGETABLES HAVE A WHOLE FESTIVAL DEVOTED TO THEM.

[MANY NEW ORLEANIANS MAKE A MEAN MIRLITON THANKSGIVING STUFFING, TOO.]

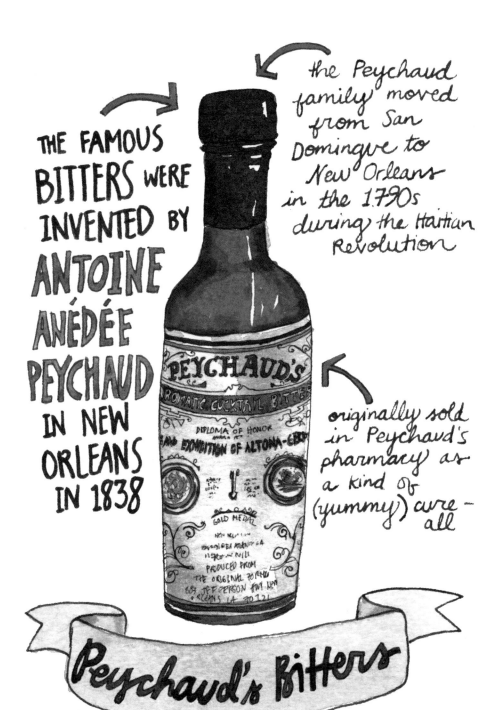

THE FAMOUS BITTERS WERE INVENTED BY ANTOINE ANÉDÉE PEYCHAUD IN NEW ORLEANS IN 1838

the Peychaud family moved from San Domingue to New Orleans in the 1790s during the Haitian Revolution

originally sold in Peychaud's pharmacy as a kind of (yummy) cure-all

Peychaud's Bitters

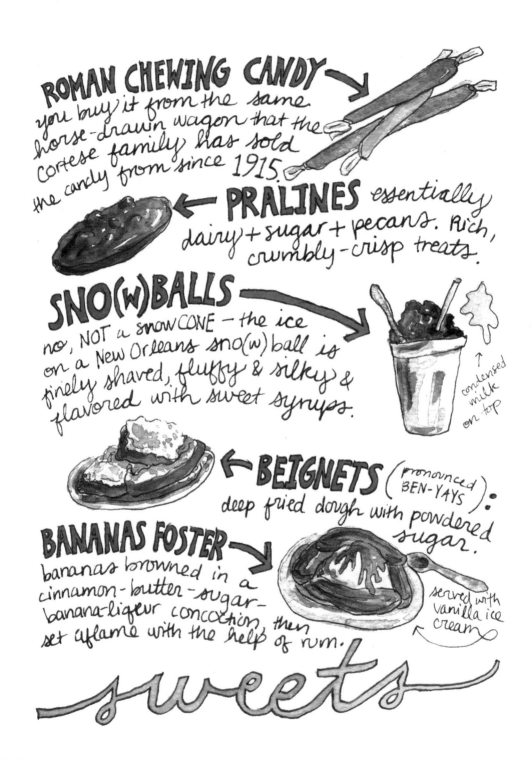

ROMAN CHEWING CANDY

you buy it from the same horse-drawn wagon that the Cortese family has sold the candy from since 1915.

PRALINES

essentially dairy + sugar + pecans. Rich, crumbly-crisp treats.

SNO(W)BALLS

no, NOT a snow CONE — the ice on a New Orleans sno(w)ball is finely shaved, fluffy & silky & flavored with sweet syrups.

↑ condensed milk on top

BEIGNETS

(pronounced BEN-YAYS):
deep fried dough with powdered sugar.

BANANAS FOSTER

bananas browned in a cinnamon-butter-sugar-banana-liqeur concoction, then set aflame with the help of rum.

served with vanilla ice cream

sweets

44

SNO-BALLS

IN NEW ORLEANS, YOU DROP THE "W"

Hansen's Sno-Bliz is one of the **oldest** (OPEN SINCE **1939**) & **most beloved** (3rd-GENERATION, FAMILY-RUN) sno-ball shops in the city. CLAIM TO FAME: THE ICE-SHAVING MACHINE MR HANSEN INVENTED (& later patented), THE FIRST OF ITS KIND. BEFORE, ICE WAS SHAVED BY HAND.

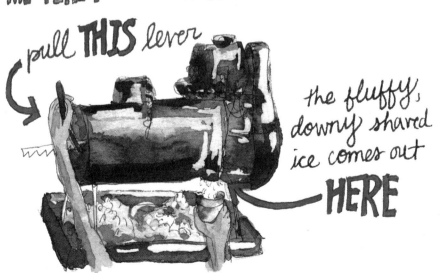

pull **THIS** lever

the fluffy, downy shaved ice comes out

HERE

the same machine from 1939 is still used today.

ONCE PLENTIFUL, NOW SCARCE, BUT
A NOLA STAPLE NONE-THE-LESS:

creole

cream cheese

A FRESH CHEESE, SEMI-TART & SEMI-
SWEET. TRADITIONALLY TOPPED WITH FRUIT.

THE LOCAL DONUT CHAIN BOUGHT McKENZIE'S RECIPES WHEN THE BAKERY CLOSED DOWN

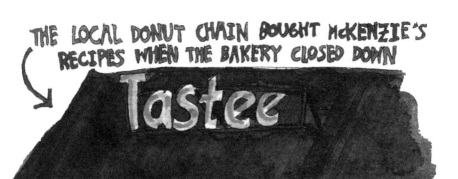

Tastee

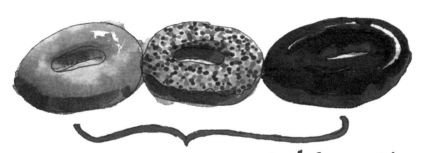

DONUTS: *airy, light, melt-in-your-mouth* (AND CHEAP, TOO!)

BUTTERMILK DROPS ✳

TURTLES ✳

DURING CARNIVAL SEASON: KING CAKE ✳

✳ McKENZIE'S RECIPE

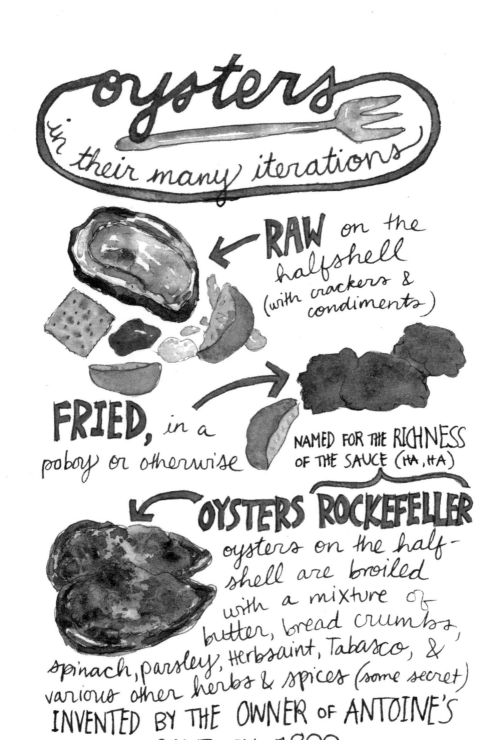

oysters
in their many iterations

RAW on the halfshell (with crackers & condiments)

FRIED, in a poboy or otherwise

NAMED FOR THE RICHNESS OF THE SAUCE (HA, HA)

OYSTERS ROCKEFELLER oysters on the half-shell are broiled with a mixture of butter, bread crumbs, spinach, parsley, Herbsaint, Tabasco, & various other herbs & spices (some secret) INVENTED BY THE OWNER OF ANTOINE'S RESTAURANT IN 1899.

HOW TO PEEL CRAWFISH *

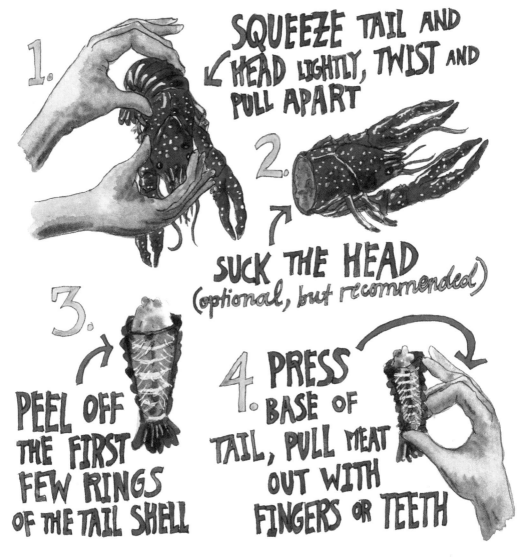

1. SQUEEZE TAIL AND HEAD LIGHTLY, TWIST AND PULL APART

2. SUCK THE HEAD (optional, but recommended)

3. PEEL OFF THE FIRST FEW RINGS OF THE TAIL SHELL

4. PRESS BASE OF TAIL, PULL MEAT OUT WITH FINGERS OR TEETH

* an essential New Orleans skill

ROADSIDE EATS:

HOT TAMALES FOR SALE spotted on Washington Ave

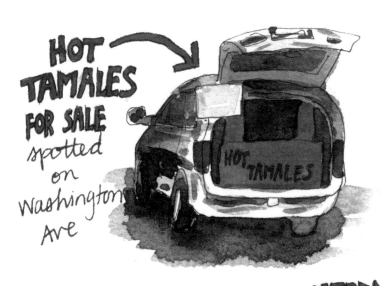

WATERMELONS FOR SALE spotted on N. Claiborne Ave

I'M A FIRM BELIEVER IN THE QUALITY OF FOOD SOLD FROM CARS & TRUCK BEDS.

buying shrimp roadside

juices
drip into
bucket

"TEN POUNDS,
PLEASE"

51

how good is your poboy?

USE THE FOLLOWING CHART TO RATE YOUR POBOY ON A SCALE OF 1 TO 4.

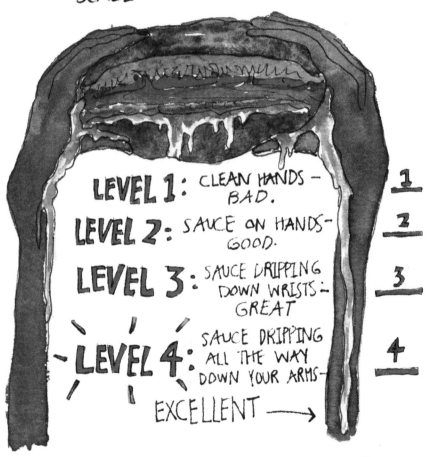

LEVEL 1: CLEAN HANDS — BAD. <u>1</u>

LEVEL 2: SAUCE ON HANDS — GOOD. <u>2</u>

LEVEL 3: SAUCE DRIPPING DOWN WRISTS — GREAT <u>3</u>

LEVEL 4: SAUCE DRIPPING ALL THE WAY DOWN YOUR ARMS — EXCELLENT ⟶ <u>4</u>

If you don't employ a small mountain of napkins, it's a bad sign.

POBOYS

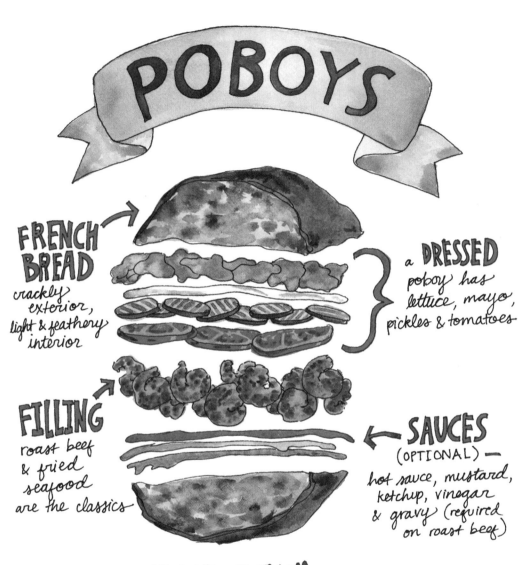

FRENCH BREAD
crackly exterior, light & feathery interior

a **DRESSED** poboy has lettuce, mayo, pickles & tomatoes

FILLING
roast beef & fried seafood are the classics

← **SAUCES** (OPTIONAL) —
hot sauce, mustard, ketchup, vinegar & gravy (required on roast beef)

SHORT FOR "POOR BOYS," A TERM COINED BY THE MARTIN BROTHERS DURING THE 1929 STREETCAR STRIKE WHEN THE BROTHERS GAVE HUNGRY STRIKERS THIS KIND OF SANDWICH FOR FREE.

COFFEE CULTURE

New Orleanians apply the same criterion to coffee that they apply to all substances: make it STRONG or not at all.

CHICORY COFFEE

the golden standard: coffee mixed with ground chicory root. What was once a necessity became a preference: the French introduced this method of coffee substitution to be used in times of scarcity & desperation, & New Orleans relied on it heavily during the Civil War & Great Depression. And they got hooked on the flavor!

SCIENTIFIC NAME IS ACTUALLY **CICHORIUM INTYBUS** VAR. SATIVUM

CAFÉ au LAIT

chicory coffee served with scalding (not steamed) milk.

ICED COFFEE is an

art here. It's cold-brewed for at LEAST 12 hours. Add milk & sugar to taste. This'll get you through the godawful heat that envelops the city 9 months of the year

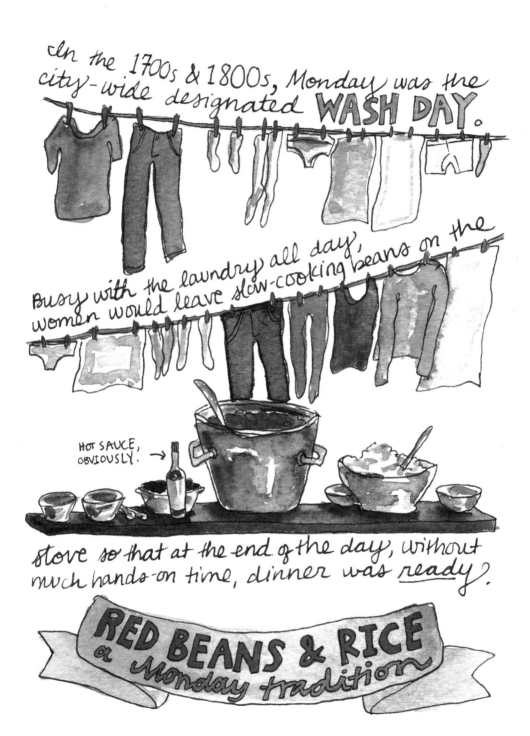

In the 1700s & 1800s, Monday was the city-wide designated **WASH DAY.**

Busy with the laundry all day, women would leave slow-cooking beans on the

HOT SAUCE, OBVIOUSLY! →

stove so that at the end of the day, without much hands-on time, dinner was _ready_.

RED BEANS & RICE
a Monday tradition

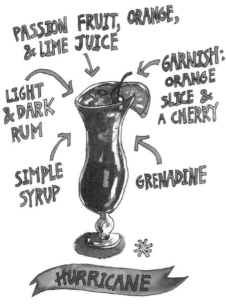

PASSION FRUIT, ORANGE, & LIME JUICE

LIGHT & DARK RUM

SIMPLE SYRUP

GARNISH: ORANGE SLICE & A CHERRY

GRENADINE

HURRICANE

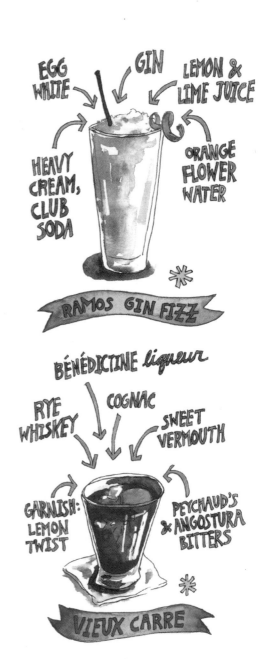

EGG WHITE

GIN

LEMON & LIME JUICE

HEAVY CREAM, CLUB SODA

ORANGE FLOWER WATER

RAMOS GIN FIZZ

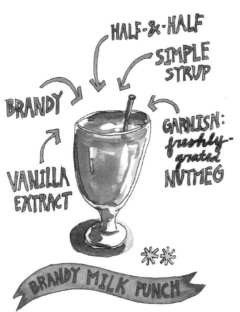

HALF-&-HALF

SIMPLE SYRUP

BRANDY

VANILLA EXTRACT

GARNISH: *freshly-grated* NUTMEG

BRANDY MILK PUNCH

BÉNÉDICTINE *liqueur*

RYE WHISKEY

COGNAC

SWEET VERMOUTH

GARNISH: LEMON TWIST

PEYCHAUD'S & ANGOSTURA BITTERS

VIEUX CARRE

ESSENTIAL
New Orleans Cocktails

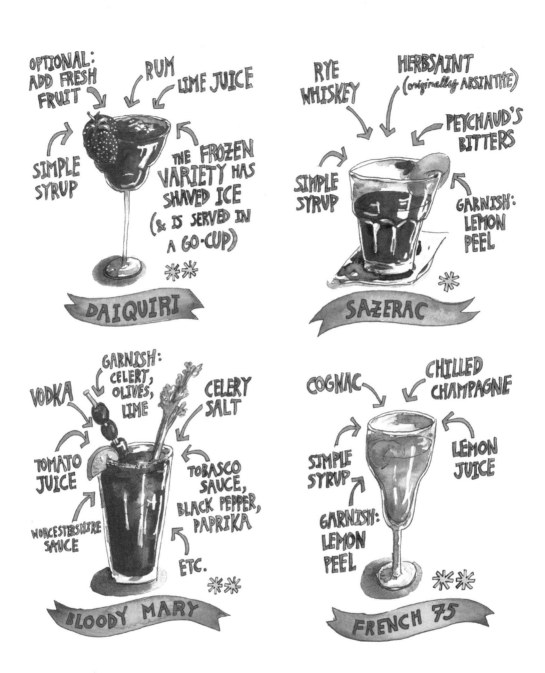

OPTIONAL: ADD FRESH FRUIT
RUM
LIME JUICE
SIMPLE SYRUP
THE FROZEN VARIETY HAS SHAVED ICE (& IS SERVED IN A GO-CUP)
✳✳

DAIQUIRI

RYE WHISKEY
HERBSAINT (*originally* ABSINTHE)
PEYCHAUD'S BITTERS
SIMPLE SYRUP
GARNISH: LEMON PEEL
✳

SAZERAC

VODKA
GARNISH: CELERY, OLIVES, LIME
CELERY SALT
TOMATO JUICE
TOBASCO SAUCE, BLACK PEPPER, PAPRIKA
WORCESTERSHIRE SAUCE
ETC.
✳✳

BLOODY MARY

COGNAC
CHILLED CHAMPAGNE
SIMPLE SYRUP
LEMON JUICE
GARNISH: LEMON PEEL
✳✳

FRENCH 75

✳ FIRST CONCOCTED HERE IN THE BIG EASY
✳✳ FIRST CONCOCTED ELSEWHERE BUT ADOPTED WITH GUSTO

MARDI
GRAS

Mardi Gras

↳ FRENCH FOR *"Fat Tuesday."*
IT'S THE DAY BEFORE **ASH WEDNESDAY,**
WHICH MARKS THE BEGINNING OF LENT
FOR CATHOLICS:

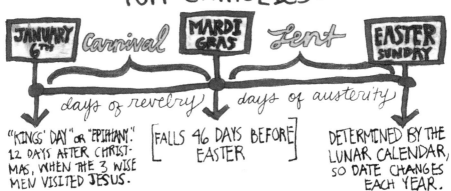

| JANUARY 6TH | *Carnival* | MARDI GRAS | *Lent* | EASTER SUNDAY |

days of revelry | *days of austerity*

"KINGS' DAY" OR "EPIPHANY." 12 DAYS AFTER CHRISTMAS, WHEN THE 3 WISE MEN VISITED JESUS.

[FALLS 46 DAYS BEFORE EASTER]

DETERMINED BY THE LUNAR CALENDAR, SO DATE CHANGES EACH YEAR.

CARNIVAL : *etymologically, comes from the Latin words* CARNEM LEVARE, *"the taking away of meat."* DURING LENT, YOU ABSTAIN FROM MEAT & OTHER LUXURIES— CARNIVAL ALLOWS YOU TO SAY A **PROPER** FAREWELL TO ALL THOSE SINFUL PLEASURES BY **INDULGING IN EXCESS.**

"THROW ME SOMETHIN' MISTER!" (OR MISSUS)

BEADS

~ huge ones that everyone goes nuts over

~ normal sized

~ those tiny ones everyone hates

EDIBLES

tootsie rolls, bubble gum

moon pies →

Moon Pie

Zapp's

Zapp's chips.

DOUBLOONS

SPEARS, STUFFED ANIMALS, FRISBEES, SHIRTS, ETC.

something about the carnival fervor will make you, a fully grown adult, go BALLISTIC to get these. after mardi gras, you will immediately forget why you wanted them.

PLASTIC CUPS AKA "mardi Gras cups" — very useful year-round.

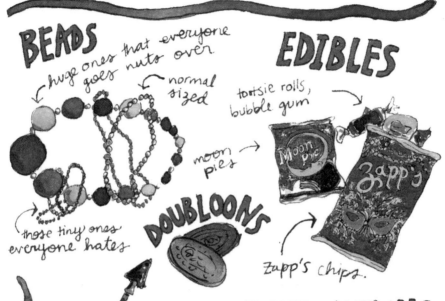

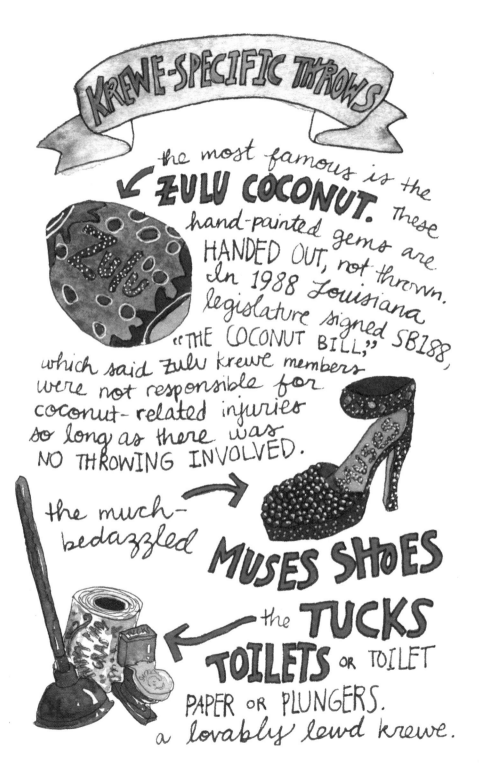

KREWE-SPECIFIC THROWS

the most famous is the **ZULU COCONUT.** These hand-painted gems are HANDED OUT, not thrown. In 1988 Louisiana legislature signed SB188, "THE COCONUT BILL," which said Zulu krewe members were not responsible for coconut-related injuries so long as there was NO THROWING INVOLVED.

the much-bedazzled **MUSES SHOES**

the **TUCKS TOILETS** OR TOILET PAPER OR PLUNGERS. a lovably lewd krewe.

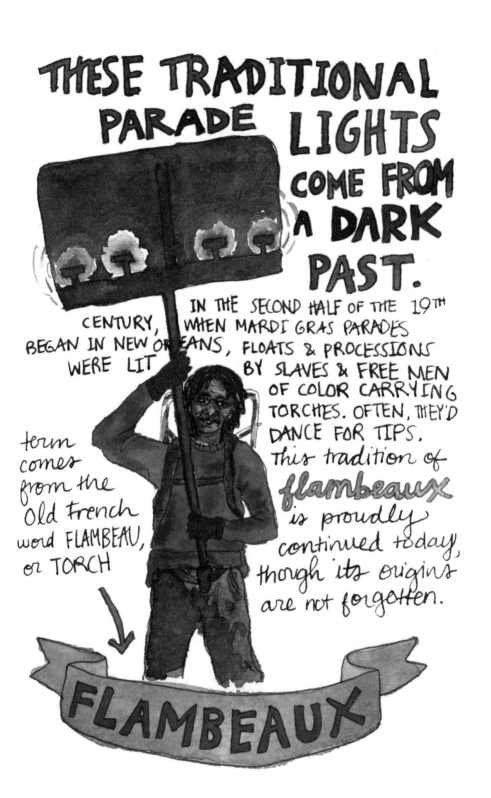

THESE TRADITIONAL PARADE LIGHTS COME FROM A DARK PAST.

IN THE SECOND HALF OF THE 19TH CENTURY, WHEN MARDI GRAS PARADES BEGAN IN NEW ORLEANS, FLOATS & PROCESSIONS WERE LIT BY SLAVES & FREE MEN OF COLOR CARRYING TORCHES. OFTEN, THEY'D DANCE FOR TIPS.

This tradition of *flambeaux* is proudly continued today, though its origins are not forgotten.

term comes from the Old French word FLAMBEAU, or TORCH

FLAMBEAUX

Mardi Gras Indians

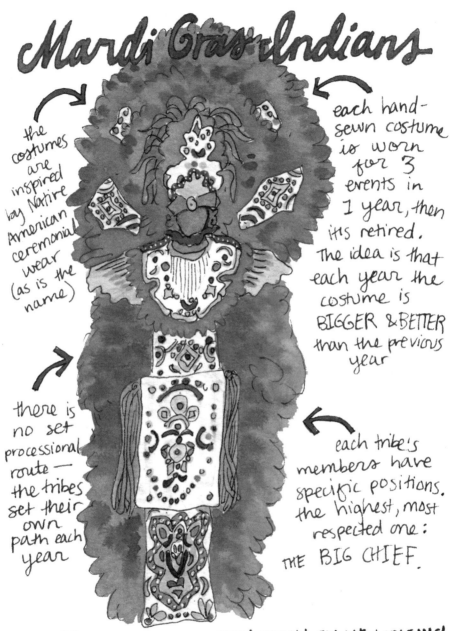

the costumes are inspired by Native American ceremonial wear (as is the name)

each hand-sewn costume is worn for 3 events in 1 year, then it's retired. The idea is that each year the costume is BIGGER & BETTER than the previous year

there is no set processional route — the tribes set their own path each year

each tribe's members have specific positions. the highest, most respected one: THE BIG CHIEF.

THIS PROCESSIONAL TRADITION BEGAN IN NEW ORLEANS' BLACK COMMUNITIES. RITUALS HAVE EVOLVED OVER THE INDIANS' 100 + YEAR HISTORY, BUT TODAY IT'S A BATTLE OF COSTUMES — OF BEAUTY, ORIGINALITY.

A SHORT-BUT-COMPREHENSIVE LIST OF THINGS THAT DANGLE FROM TREES:

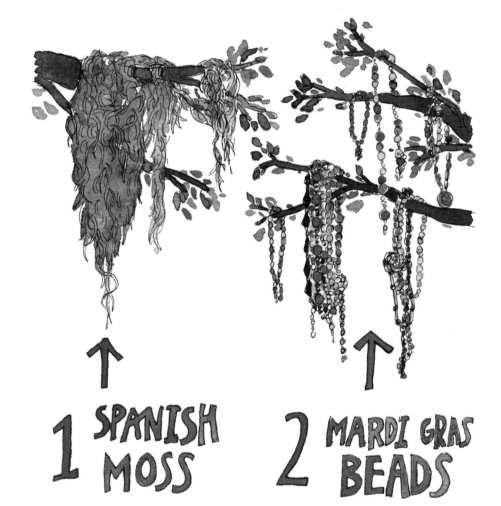

1 SPANISH MOSS

2 MARDI GRAS BEADS

list complete.

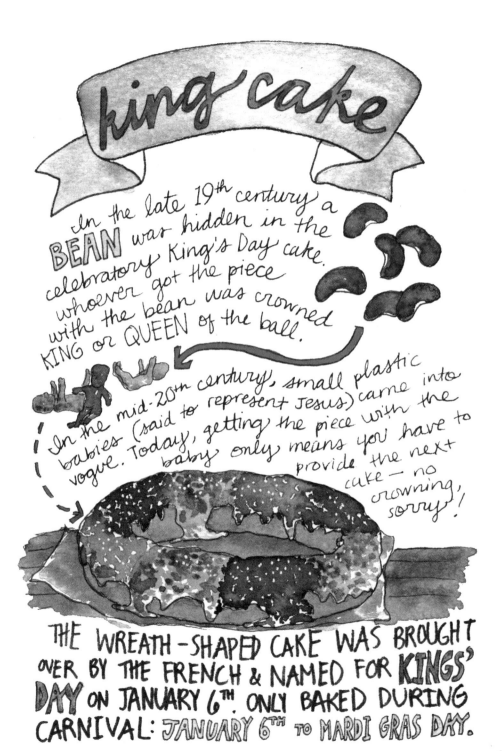

king cake

In the late 19th century a **BEAN** was hidden in the celebratory King's Day cake. whoever got the piece with the bean was crowned KING or QUEEN of the ball.

In the mid-20th century, small plastic babies (said to represent Jesus) came into vogue. Today, getting the piece with the baby only means you have to provide the next cake — no crowning, sorry!

THE WREATH-SHAPED CAKE WAS BROUGHT OVER BY THE FRENCH & NAMED FOR **KINGS' DAY** ON JANUARY 6TH. ONLY BAKED DURING CARNIVAL: JANUARY 6TH TO MARDI GRAS DAY.

65

THE 7 PEOPLE YOU SEE AT MARDI GRAS

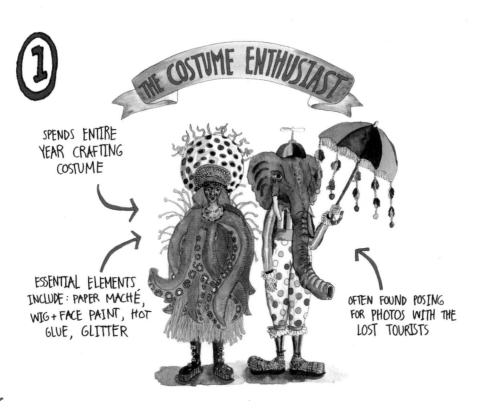

① THE COSTUME ENTHUSIAST

SPENDS ENTIRE
YEAR CRAFTING
COSTUME

ESSENTIAL ELEMENTS
INCLUDE: PAPER MACHÉ,
WIG + FACE PAINT, HOT
GLUE, GLITTER

OFTEN FOUND POSING
FOR PHOTOS WITH THE
LOST TOURISTS

② THE CUTE KID

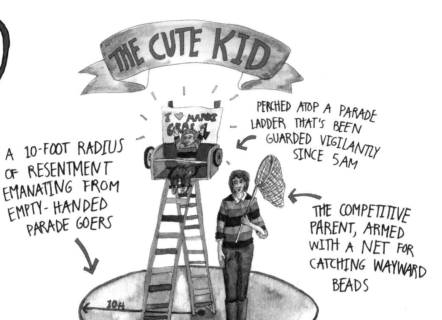

A 10-FOOT RADIUS OF RESENTMENT EMANATING FROM EMPTY-HANDED PARADE GOERS

I ♥ MARDI GRAS

10 ft

PERCHED ATOP A PARADE LADDER THAT'S BEEN GUARDED VIGILANTLY SINCE 5AM

THE COMPETITIVE PARENT, ARMED WITH A NET FOR CATCHING WAYWARD BEADS

③ THE VICIOUS GRANNY

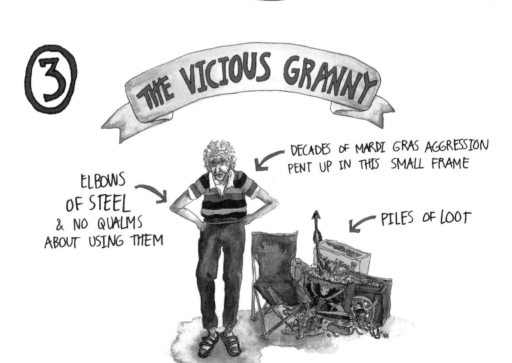

DECADES OF MARDI GRAS AGGRESSION PENT UP IN THIS SMALL FRAME

ELBOWS OF STEEL & NO QUALMS ABOUT USING THEM

PILES OF LOOT

67

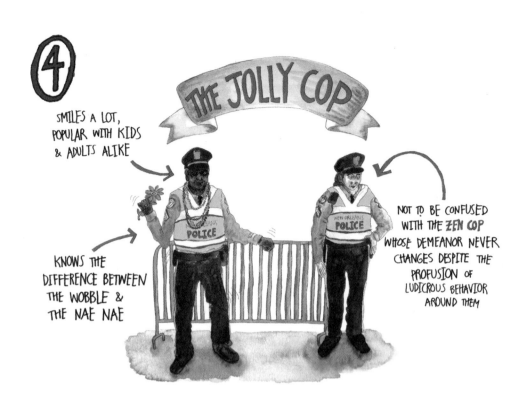

④ THE JOLLY COP

SMILES A LOT, POPULAR WITH KIDS & ADULTS ALIKE

KNOWS THE DIFFERENCE BETWEEN THE WOBBLE & THE NAE NAE

POLICE

NEW ORLEANS POLICE

NOT TO BE CONFUSED WITH THE ZEN COP WHOSE DEMEANOR NEVER CHANGES DESPITE THE PROFUSION OF LUDICROUS BEHAVIOR AROUND THEM

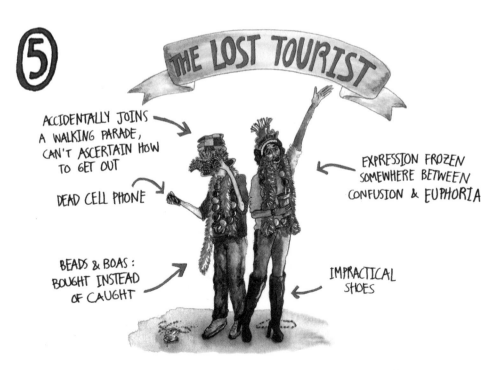

⑤ THE LOST TOURIST

ACCIDENTALLY JOINS A WALKING PARADE, CAN'T ASCERTAIN HOW TO GET OUT

DEAD CELL PHONE

BEADS & BOAS: BOUGHT INSTEAD OF CAUGHT

EXPRESSION FROZEN SOMEWHERE BETWEEN CONFUSION & EUPHORIA

IMPRACTICAL SHOES

THE TROUPE STRAGGLERS

GLAZED EXPRESSION

LOPSIDED OR MISSING COSTUME PIECES

PROBABLY RIDING ON THE BACK OF A TRUCK BED

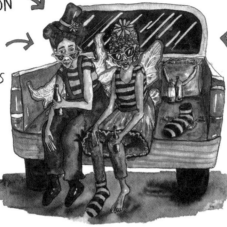

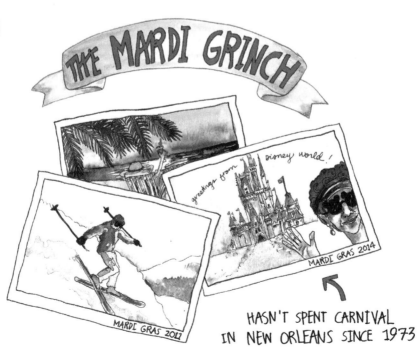
THE MARDI GRINCH

greetings from disney world!

MARDI GRAS 2014

MARDI GRAS 2011

HASN'T SPENT CARNIVAL IN NEW ORLEANS SINCE 1973

FRENCH QUARTER

A BRIEF TIMELINE

OF THE FRENCH QUARTER

1718 BIENVILLE FOUNDS THE VIEUX CARRÉ AS A 12-BY-6 BLOCK GRID

MOSTLY POPULATED BY WEALTHY FRENCH CREOLES

1762 FRANCE TRANSFERS NEW ORLEANS TO SPAIN. SPANISH COLONIAL PERIOD

1788 GREAT FIRE BURNS MOST OF THE QUARTER, FOLLOWED BY A SECOND MAJOR FIRE IN 1794

1803 THE LOUISIANA PURCHASE: NEW ORLEANS IS OFFICIALLY AN AMERICAN CITY

1850s TO 1900s FALLS INTO DISREPAIR. MOSTLY POPULATED BY IMMIGRANTS (SICILIAN, IRISH, ETC)

1936 VIEUX CARRÉ COMMISSION CREATED TO SAVE THE QUARTER FROM BEING RAZED

1960s MAJOR COMMERCIAL INVESTMENT

TODAY

71

JACKSON SQUARE

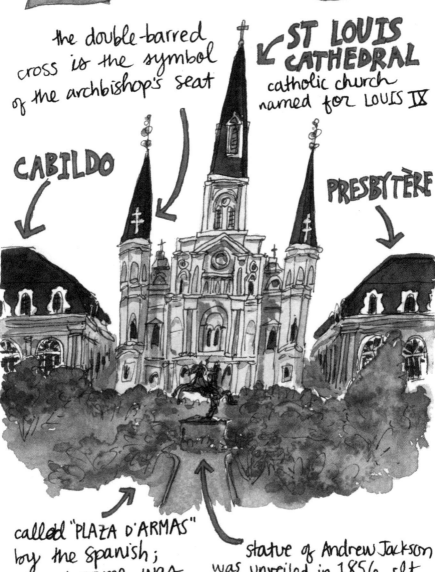

the double-barred cross is the symbol of the archbishop's seat

ST LOUIS CATHEDRAL
catholic church named for LOUIS IX

CABILDO

PRESBYTÈRE

called "PLAZA D'ARMAS" by the Spanish; current name was adopted in 1851

statue of Andrew Jackson was unveiled in 1856. It weighs 15 tons.

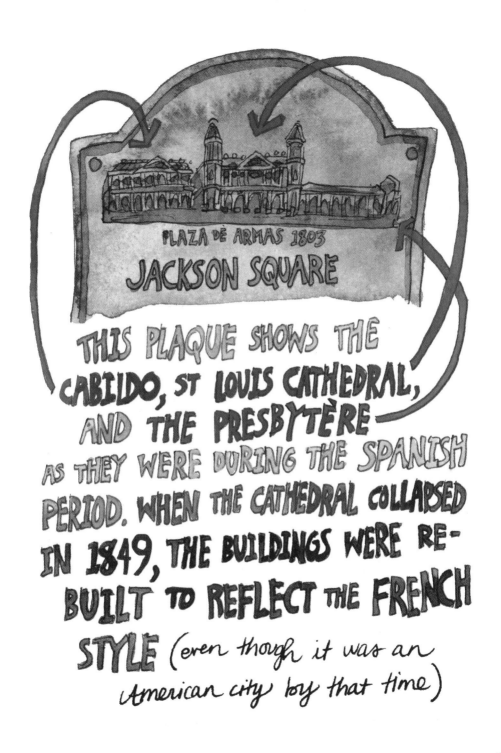

PLAZA DE ARMAS 1803

JACKSON SQUARE

THIS PLAQUE SHOWS THE CABILDO, ST LOUIS CATHEDRAL, AND THE PRESBYTÈRE AS THEY WERE DURING THE SPANISH PERIOD. WHEN THE CATHEDRAL COLLAPSED IN 1849, THE BUILDINGS WERE RE-BUILT TO REFLECT THE FRENCH STYLE (even though it was an American city by that time)

THE UPPER & LOWER Pontalba BUILDINGS

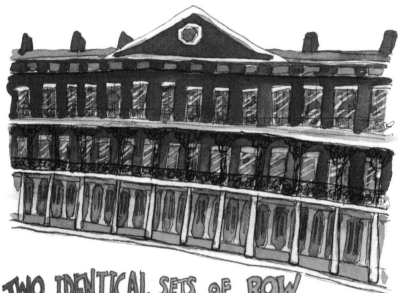

TWO IDENTICAL SETS OF ROW HOUSES (16 EACH) FLANK JACKSON SQUARE. MICAELA DE PONTALBA PAID FOR THEM & OVERSAW DESIGN.

[AFTER HER FATHER-IN-LAW TRIED TO KILL HER, MICAELA WAS GRANTED SOLE CLAIM TO HER FATHER'S ALMONESTER FORTUNE. SHE BECAME A SHREWD BUSINESSWOMAN].

look closely at the cast iron & you'll see Micaela signed her work: A for ALMONESTER & P for PONTALBA

WHAT A TALE! WHAT A LADY! BORN TO THE WEALTHY ALMONESTER FAMILY, SHE HAD THE MISFORTUNE OF MARRYING CÉLESTIN DE PONTALBA, WHOSE AVARICIOUS FATHER TRIED TO MURDER MICAELA IN FRANCE IN 1834 SO HE COULD ACCESS THE REST OF HER INHERITANCE. HE SHOT HER MULTIPLE TIMES: FOUR BULLETS LANDED IN HER CHEST, ANOTHER BLEW OFF TWO FINGERS. SHE SURVIVED (!), GOT A SEPARATION FROM HER HUSBAND, & RETURNED TO NEW ORLEANS.

Baroness Micaela de Pontalba

A ROW OF TOWNHOUSES

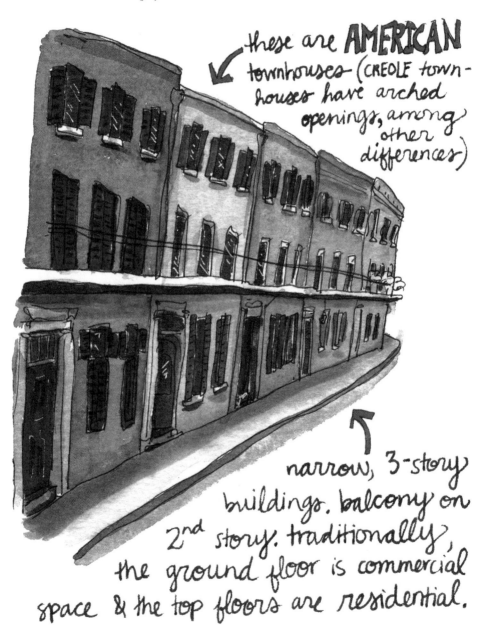

these are **AMERICAN** townhouses (CREOLE townhouses have arched openings, among other differences)

narrow, 3-story buildings. balcony on 2nd story. traditionally, the ground floor is commercial space & the top floors are residential.

TRADITIONAL BRASS BANDS PLAYING ON THE STREETS

FOLKS DOCUMENTING THEIR EXPERIENCE
(SOME MORE CONSPICUOUSLY THAN OTHERS)

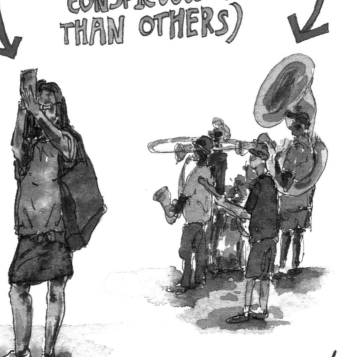

street performers know how to give visitors the New Orleans of lore. a certain air of self-awareness

URSULINE CONVENT

THE URSULINE NUNS, A CATHOLIC ORDER FROM FRANCE, CAME TO NEW ORLEANS IN THE EARLY 1700s. THEY ESTABLISHED A SCHOOL FOR GIRLS & WOMEN, AN ORPHANAGE, AND A HOSPITAL.

BUILT 1752

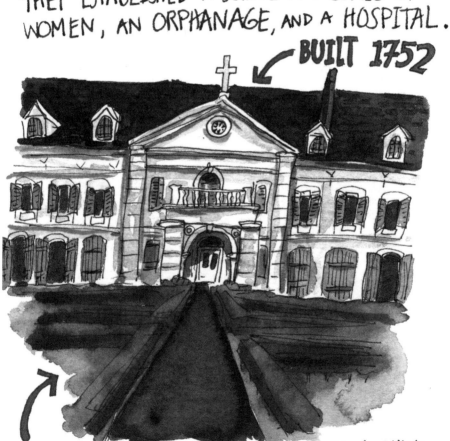

one of the few structures (along with Lafitte's Blacksmith shop) to survive the great fires of 1788 and 1794

LAFITTE'S BLACK-SMITH SHOP BAR

OLDEST STRUCTURE USED AS A BAR IN THE U.S. — built between 1722 and 1732.

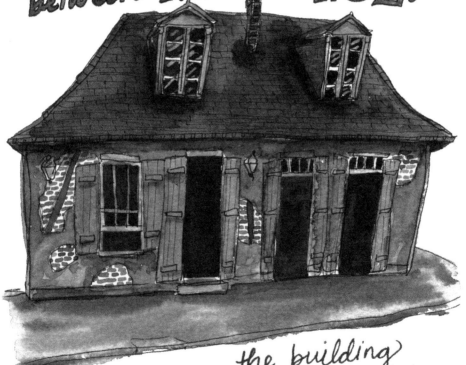

the building survived the great fire of 1788 that destroyed almost **80%** of the city's buildings. IT'S ONE OF THE **BEST** (& ONLY) SURVIVING EXAMPLES of **EARLY** FRENCH COLONIAL ARCHITECTURE.

IRONWORK:

AN ESSENTIAL ELEMENT OF THE FRENCH QUARTER AESTHETIC

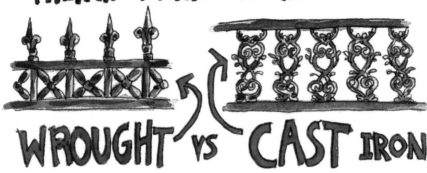

WROUGHT VS CAST IRON

- SIMPLER, HEAVIER DESIGNS
- EACH PIECE WORKED BY HAND (HAMMERED, BENT, ETC)
- STRONGER, HOLDS UP TO ELEMENTS

- MORE ORNATE & DELICATE DESIGNS
- LIQUID IRON POURED INTO MOLDS

IRON HORSE-HITCHING POSTS PEPPER THE SIDEWALKS

the most common square shape

the iconic copper lamps

PEOPLE USED TO BURN **PELICAN GREASE** (the "dirty" option) OUTSIDE & **WHALE OIL** (the "clean" one) INSIDE. Individuals had to carry lanterns at night until 1796, when Carondelet mandated city-wide public lighting. Lamps were installed & guarded by police (!) — NEW ORLEANS WAS LIT FOR THE FIRST TIME.

THE ONES YOU SEE TODAY MIGHT LOOK OLD BUT MOST OF THEM WERE ACTUALLY MADE IN THE 1980s

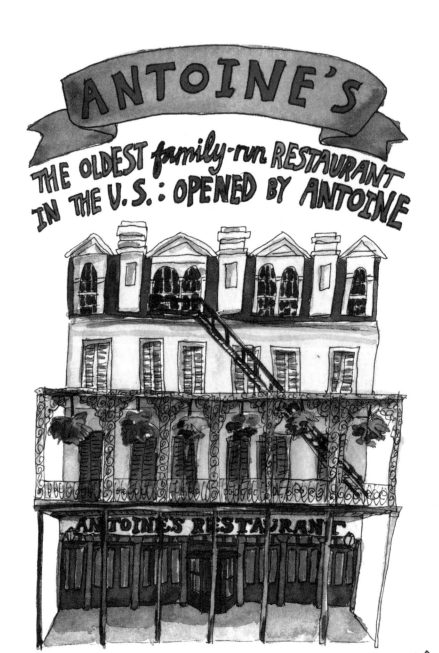

ANTOINE'S

THE OLDEST *family-run* RESTAURANT IN THE U.S.: OPENED BY ANTOINE ALCIATORE IN 1840, TODAY IT'S RUN BY ANTOINE'S GREAT-GREAT GRANDSON RICK.

oysters rockefeller

CREATED AT ANTOINE'S RESTAURANT; GOT THEIR NAME BECAUSE THE SAUCE IS SO RICH.

(JOHN D ROCKEFELLER WAS THE RICHEST AMERICAN AT THE TIME).

secret recipe contains mysterious green vegetables said NOT to be spinach.

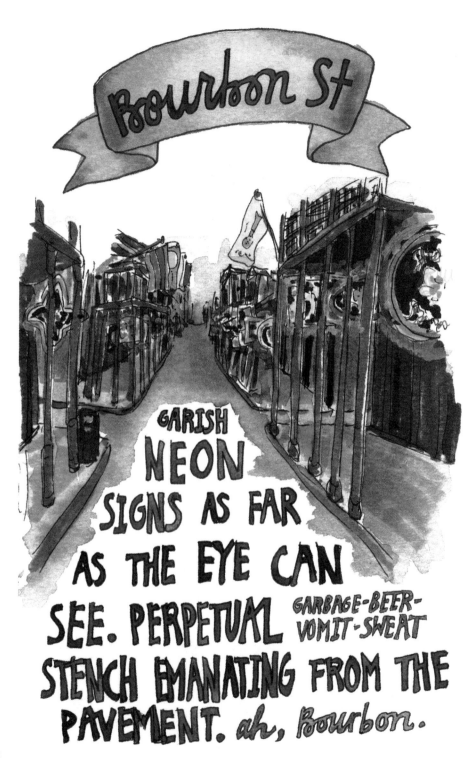

Bourbon

PERPETUALLY SMELLS LIKE A DANK, BEER-SOAKED CARPET.

THINGS IN HANDS INCLUDE:

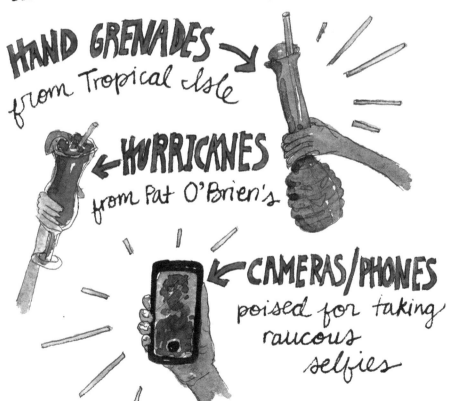

HAND GRENADES
from Tropical Isle

HURRICANES
from Pat O'Brien's

CAMERAS/PHONES
poised for taking raucous selfies

see it. smell it. move along.

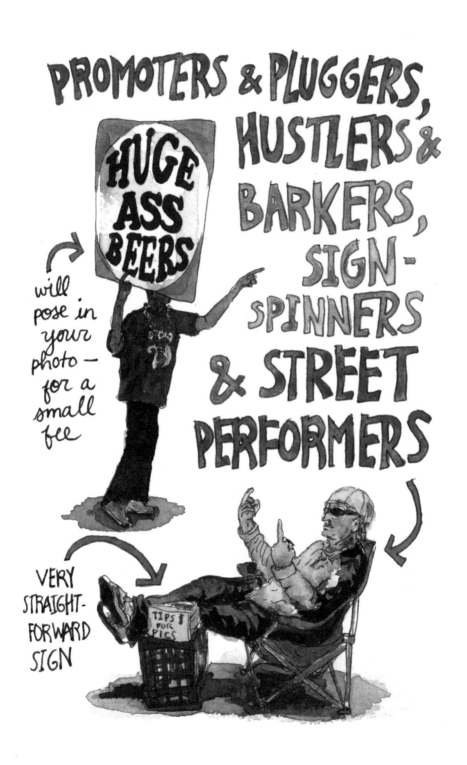

PROMOTERS & PLUGGERS, HUSTLERS' & BARKERS, SIGN-SPINNERS & STREET PERFORMERS

will pose in your photo — for a small fee

VERY STRAIGHT-FORWARD SIGN

TAROT-CARD-& PALM-READERS, FORTUNE TELLERS & CLAIRVOYANTS

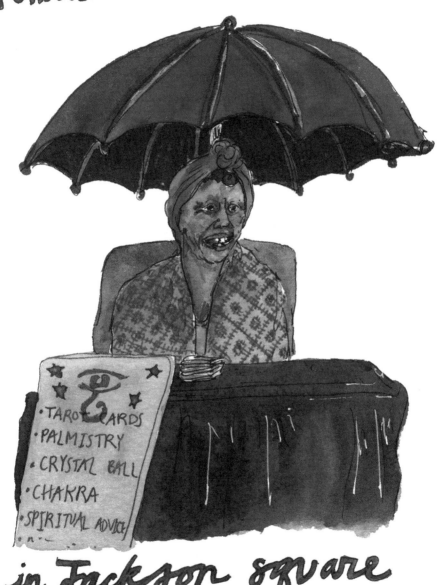

in Jackson square

THE VIVID NEON-GREEN, SUPER-SWEET HAND GRENADES FROM TROPICAL ISLE CAN BE SPOTTED IN THE GRIP of MANY-A-TOURIST THROUGHOUT THE QUARTER. BUT ORDER THEIR SHARK ATTACK FOR A REAL SHOW:

vodka &
clear mixer with plastic
alligator floating
atop

plastic shark, mouth
filled with grenadine
syrup, nose-dives
into your cup

1

2

3

4

you
drink

NOTE: BARTENDER BLOWS WHISTLE & SCREAMS "SHARK ATTACK" FOR THE DURATION OF THESE STEPS.

thus "blood" pours as
shark "eats" the
alligator

THE SAME KITSCH SOUVENIRS SPILL OUT OF EVERY BOURBON ST SHOP

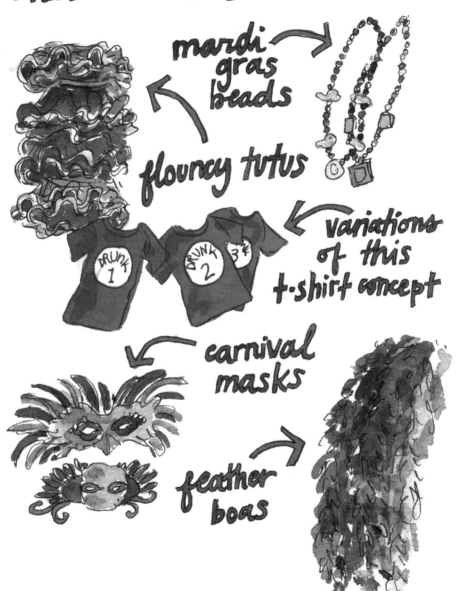

mardi gras beads

flouncy tutus

variations of this t-shirt concept

DRUNK 1 · DRUNK 2 · 3

carnival masks

feather boas

AN ICONIC NEW ORLEANS VENDOR, STARTED IN 1948 & JOLTED TO CELEBRITY STATUS IN 1980 WHEN IT WAS INCLUDED

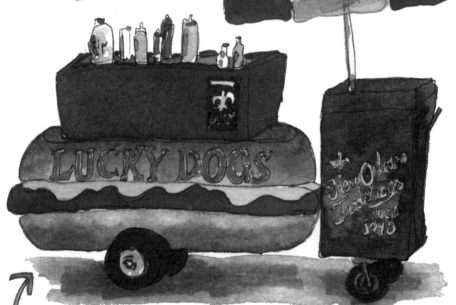

IN J.K.TOOLE'S FRENCH-QUARTER-BASED NOVEL *A CONFEDERACY OF DUNCES*.

find the 10-foot-long pushcarts in the French Quarter & beyond

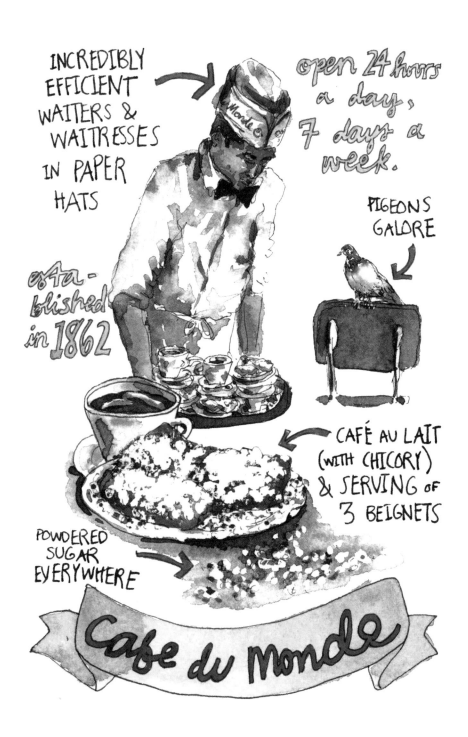

INCREDIBLY EFFICIENT WAITERS & WAITRESSES IN PAPER HATS

open 24 hours a day, 7 days a week.

PIGEONS GALORE

established in 1862

CAFÉ AU LAIT (WITH CHICORY) & SERVING OF 3 BEIGNETS

POWDERED SUGAR EVERYWHERE

Café du Monde

GALATOIRE'S IS AS CELEBRATED FOR ITS WAITERS & OLD-SCHOOL SERVICE AS IT IS FOR ITS FOOD. IMRÉ HAS WORKED HERE FOR OVER 40 YEARS. THIS WAS HIS FIRST JOB IN THE U.S. AFTER HE ARRIVED FROM HUNGARY IN THE 1970s —HE SAYS HE OWES EVER-YTHING TO THE GENEROSITY OF GALATOIRE'S OWNERS & PATRONS.

WHEN IMRÉ STARTED, HIS FELLOW WAITERS WERE "CRAZY CAJUNS" WHO SHOWED HIM THE ROPES (WITH LOTS OF PRACTICAL JOKES ALONG THE WAY).

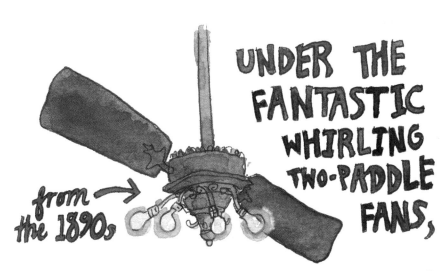

UNDER THE FANTASTIC WHIRLING TWO-PADDLE FANS,

from → the 1890s

ENJOY GALATOIRE'S CLASSICS:

← BRANDY MILK PUNCH

GRAND GOUTÉ: CRABMEAT MAISON, SHRIMP REMOULADE, OYSTERS EN BROCHETTE

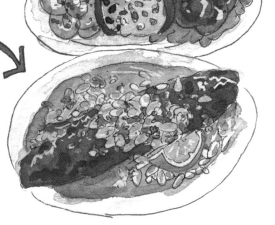

FRIED GULF FISH AMANDINE

CAROUSEL BAR

in Hotel Montelone

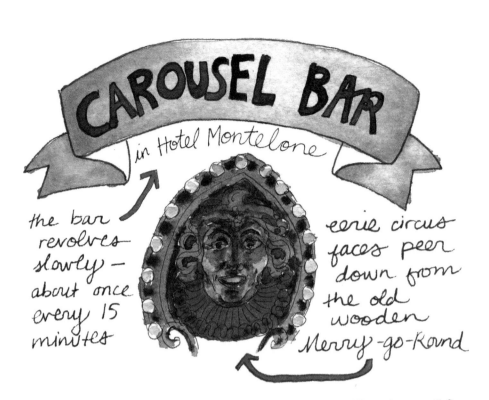

the bar revolves slowly — about once every 15 minutes

eerie circus faces peer down from the old wooden Merry-go-Round

I ORDERED THEIR SIGNATURE DRINK, THE VIEUX CARRE:

RYE WHISKEY, COGNAC, SWEET VERMOUTH, BÉNÉDICTINE, ANGOSTURA + PEYCHAUD'S BITTERS.

[FUN FACT: the only way in/out of the Carousel Bar (inside which the drinks are served) is OVER — if you stick around, you'll see bartenders clambering across]

BUILT IN 1927. HIT HARD BY
HURRICANE KATRINA IN 2005.
PAINSTAKINGLY
RESTORED
TO ITS
ORIGINAL
"FLORENTINE
SPLENDOR"
AND RE-
OPENED
IN 2013.

an opulent
reproduction
of the original
1927 sign

S
A
E
N
G
E
R

SAENGER

CONCERT
TONIGHT
8 PM

GROUP SALES 504 287 0372

THE SAENGER
THEATER
ON CANAL
STREET.

"florentine splendor"

MATASSA'S MARKET HAS BEEN OPEN SINCE 1924 - FIRST AS JOHNNY'S GROCERY & BAR, OPENED BY JOHN MATASSA. JOHN'S GRANDSONS, JOHN & LOUIS, ARE NOW AT THE HELM.

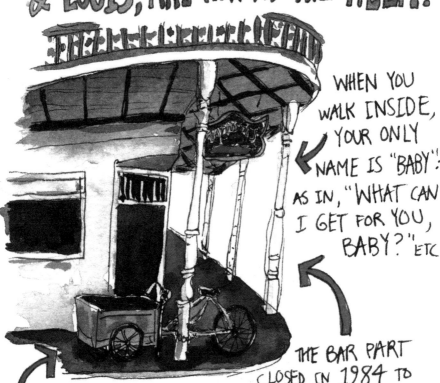

WHEN YOU WALK INSIDE, YOUR ONLY NAME IS "BABY": AS IN, "WHAT CAN I GET FOR YOU, BABY?" ETC

THE BAR PART CLOSED IN 1984 TO MAKE MORE ROOM FOR GROCERIES. GET DELICIOUS HOT FOOD IN THE BACK.

DELIVERY BIKE FOR HOT FOOD, GROCERIES

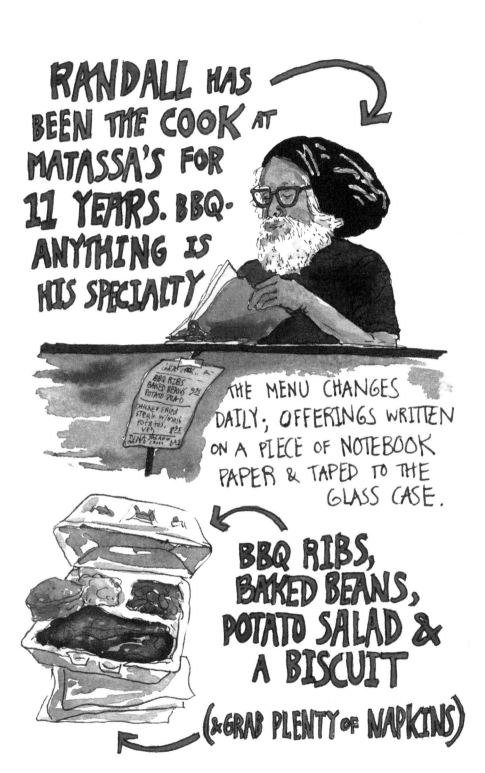

RANDALL HAS BEEN THE COOK AT MATASSA'S FOR 11 YEARS. BBQ-ANYTHING IS HIS SPECIALTY

THE MENU CHANGES DAILY; OFFERINGS WRITTEN ON A PIECE OF NOTEBOOK PAPER & TAPED TO THE GLASS CASE.

BBQ RIBS, BAKED BEANS, POTATO SALAD & A BISCUIT

(& GRAB PLENTY OF NAPKINS)

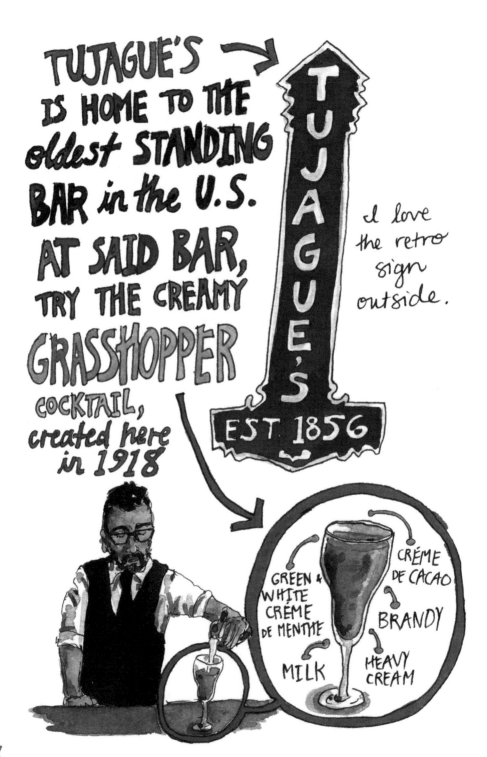

TUJAGUE'S IS HOME TO THE oldest STANDING BAR in the U.S. AT SAID BAR, TRY THE CREAMY GRASSHOPPER COCKTAIL, created here in 1918

TUJAGUE'S EST. 1856

I love the retro sign outside.

GREEN & WHITE CRÈME DE MENTHE

CRÉME DE CACAO

BRANDY

MILK

HEAVY CREAM

a Tujague's classic:

EMANATES RICH GARLICKY AROMAS

A VISUAL SHOW-STOPPER — YOU'LL HEAR OTHER DINERS WHISPER "WHAT'S *THAT*?"

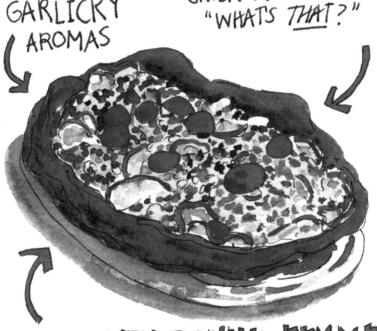

CHICKEN BONNE FEMME HAS <u>ALWAYS</u> BEEN OFF-THE-MENU — WHICH IS WHY IT'S NICKNAMED "SECRET CHICKEN." LOCALS TYPICALLY ORDER IT AS AN APPETIZER (½ CHICKEN FOR 4, WHOLE CHICKEN FOR 8)

"a New Orleans tradition since 1946"
Bananas Foster was created here in 1951 &
lavish breakfasts are a tradition.

EGGS
SARDOU →

CARIBBEAN
MILK PUNCH →

← TURTLE
SOUP

BANANAS FOSTER →
CREATED BY ELLA
BRENNAN AS A WAY
TO USE THE ABUN-
DANCE OF IMPORTED
BANANAS

BRENNAN'S

décor details

← ROOSTERS ROOSTERS EVERYWHERE: a symbol of morning, a nod to the famous "BREAKFAST AT BRENNAN'S"

WALLS, BOW TIES, UPHOLSTERY, AWNINGS, ETC: all colored a very specific shade of pink called "TOMATO CREAM SAUCE"

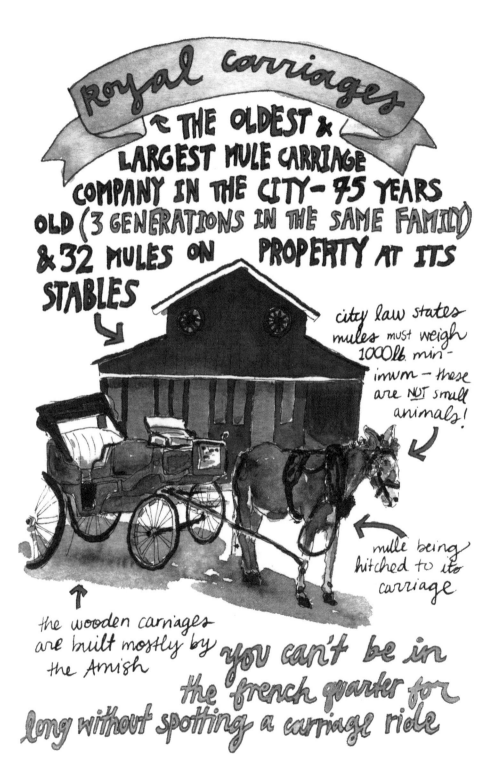

Royal carriages

~ THE OLDEST & LARGEST MULE CARRIAGE COMPANY IN THE CITY - 75 YEARS OLD (3 GENERATIONS IN THE SAME FAMILY) & 32 MULES ON PROPERTY AT ITS STABLES

city law states mules must weigh 1000lb. minimum — these are NOT small animals!

mule being hitched to its carriage

the wooden carriages are built mostly by the Amish

you can't be in the french quarter for long without spotting a carriage ride

THIS UNMARKED SPOT

AT THE CORNER OF CHARTRES & ST LOUIS STREETS WAS A **SLAVE EXCHANGE** SITE. FROM THE EARLY- TO MID-1800s, THE ROTUNDA OF THE LUXURIOUS ST LOUIS HOTEL HELD LARGE SLAVE AUCTIONS.

a faded part of the word "EXCHANGE" is still visible

I think it's a disgrace that the spot is not marked — no plaque, nothing. In fact only 2 of the 52 slave market sites in New Orleans are marked.

BLACK-AND-WHITE-CLAD WAITERS ON A SMOKE BREAK.

a familiar French Quarter tableau

french quarter
CAST IRON + FOLIAGE

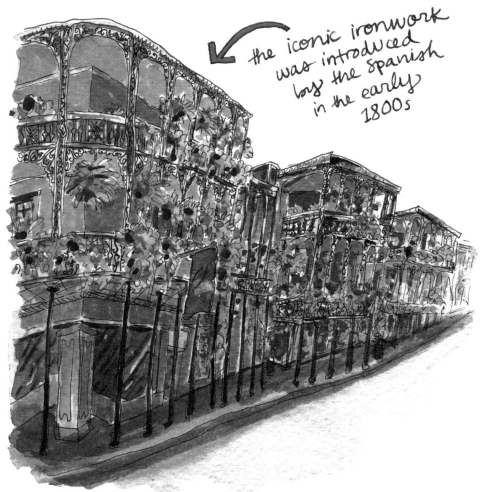

the iconic ironwork was introduced by the Spanish in the early 1800s

interplay of organic forms, some rendered in rigid metal and others composed of supple leaves. A WINNING COMBINATION.

INLAID-TILE PLACARDS ON BUILDINGS REMIND US OF THE MANY-LAYERED PAST.

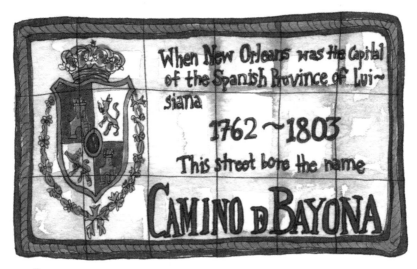

When New Orleans was the Capital of the Spanish Province of Lui~siana

1762 ~ 1803

This street bore the name

CAMINO ᴅ BAYONA

↰ *Dauphine Street, formerly camino de Bayona*

SPANISH COLONIAL RULE LASTED FROM 1762 TO 1802 AND LEFT A LASTING FOOTPRINT IN THE ARCHITECTURE OF THE FRENCH QUARTER.

a proliferation of "NO PARKING" SIGNS, FEATURING

NO PARKING
NOT 5 MINUTES
NOT 30 SECONDS
NOT AT ALL!

VARYING DEGREES OF CREATIVITY & AGGRESSION

NO PARKING
UNAUTHORIZED
VEHICLES WILL BE
TOWED AWAY
AT VEHICLE
OWNER'S EXPENSE

driving in the Quarter is bad enough — parking is worse.

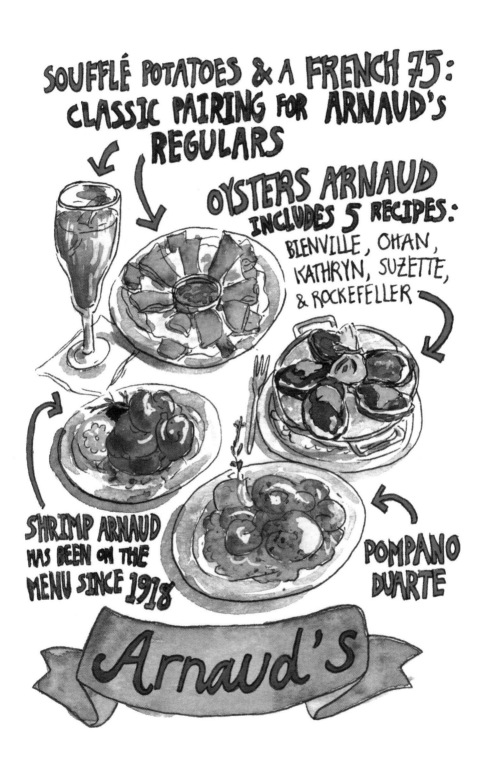

SOUFFLÉ POTATOES & A FRENCH 75: CLASSIC PAIRING FOR ARNAUD'S REGULARS

OYSTERS ARNAUD INCLUDES 5 RECIPES: BIENVILLE, OHAN, KATHRYN, SUZETTE, & ROCKEFELLER

SHRIMP ARNAUD HAS BEEN ON THE MENU SINCE 1918

POMPANO DUARTE

Arnaud's

A SURVEY of TILED FLOORS

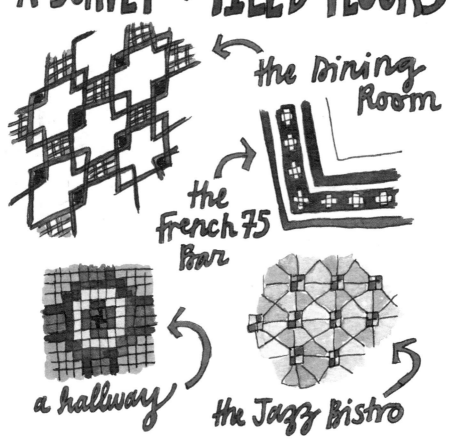

the Dining Room

the French 75 Bar

a hallway

the Jazz Bistro

ARNAUD'S KEPT THE ORIGINAL REFINED TILE FLOORS IN ITS BARS & DINING ROOMS. "you can tell where you are by the floors"— USEFUL, CONSIDERING THERE ARE 11 BUILDINGS & 17 DINING ROOMS

DOWNTOWN

ST AUGUSTINE CHURCH

WHEN CHURCH SEATS WERE PUT UP FOR SALE IN 1842, WHITES AND FREE PEOPLE OF COLOR VIED TO OUT-BUY EACH OTHER, RESULTING IN "THE WAR OF THE PEWS."

conse-crated in 1841

FREE PEOPLE OF COLOR WON THE "WAR," OUT-BUYING THE WHITE CREOLES 3:1. THEY THEN GAVE A PORTION OF THEIR SEATS TO SLAVES, MAKING THIS ONE OF THE FIRST INTEGRATED CHURCHES IN THE COUNTRY.

on the side of the church, there's the TOMB OF THE UNKNOWN SLAVE, erected here in 2004

111

ST LOUIS CEMETERY NO. 1

ACCESS HAS BEEN MORE TIGHTLY REGULATED DUE TO VANDALISM: A COMPLETELY BOGUS BUT WIDELY CIRCULATED MYTH ENCOURAGES PEOPLE TO MARK THIS TOMB WITH 3 Xs, KNOCK 3 TIMES, SPIN AROUND & MAKE A WISH. (THIS IS NOT VOO-DOO. IT IS DES-TRUCTIVE NONSENSE)

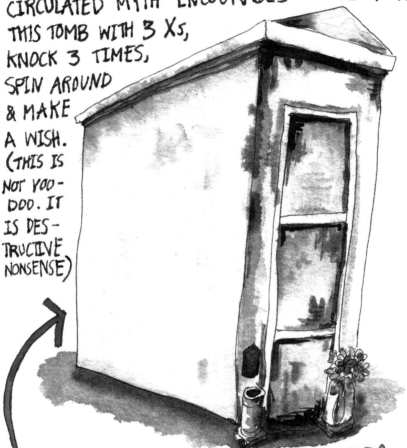

MARIE LAVEAU, LEGENDARY VOODOO PRIESTESS, is buried here. St Louis No. 1 is the city's oldest remaining cemetery.

Marie Laveau

"VOODOO PRIESTESS" OR "VOODOO QUEEN."

VERY LITTLE IS KNOWN ABOUT HER LIFE— EVEN THIS PAINTING BY FRANK SNEIDER (CIRCA 1920) IS BASED ON AN EARLIER, NOW-LOST PAINTING BY GEORGE CATLIN (CIRCA 1835). WE KNOW THIS: SHE WAS BORN IN 1801 AS A FREE WOMAN OF COLOR & IS CREDITED WITH POP-ULARIZING VOODOO DURING HER LIFE-TIME. SHE DIED IN 1881.

(voodoo is a religion that combines Catholic & West African rituals & belief systems.)

the Carver Theater

WAS BUILT IN 1950 AS A MOVIE THEATER FOR THE AFRICAN AMERICAN COMMUNITY (NEW ORLEANS WAS SEGREGATED AT THE TIME).

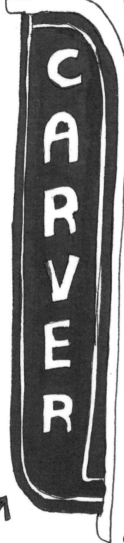

the restored, iconic red sign

The Carver became a health clinic in 1980. It was severely damaged in Hurricane Katrina in 2005.

IT UNDERWENT A MULTI-MILLION DOLLAR RESTORATION IN 2014.

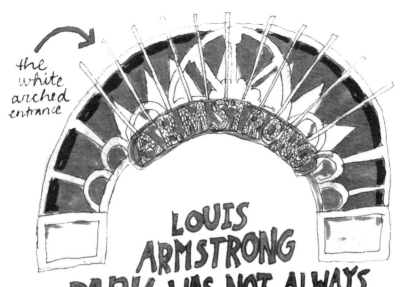

the white arched entrance

LOUIS ARMSTRONG PARK WAS NOT ALWAYS THE SERENE SPACE IT IS TODAY: ONE PORTION WAS CONGO SQUARE, WHERE SLAVES WERE ALLOWED TO CONGREGATE — FREE TO DANCE, SING & CELEBRATE — ON SUNDAYS. JAZZ'S ROOTS ARE HERE.

the Reimann House, originally a fire station built circa 1880, is also in the park

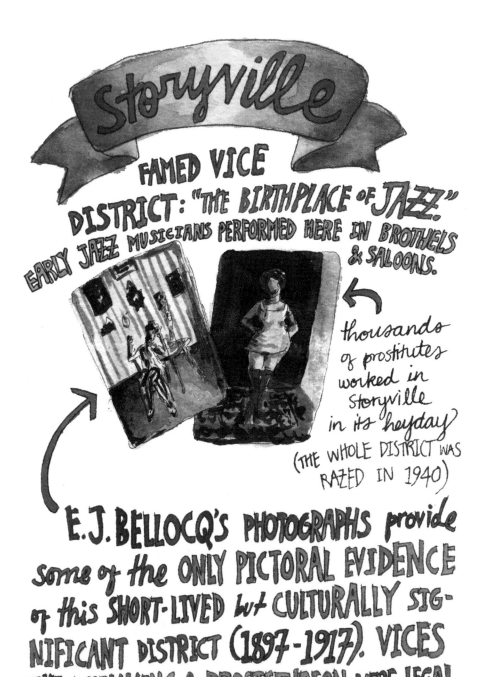

Storyville

FAMED VICE DISTRICT: "THE BIRTHPLACE OF JAZZ." EARLY JAZZ MUSICIANS PERFORMED HERE IN BROTHELS & SALOONS.

thousands of prostitutes worked in Storyville in its heyday (THE WHOLE DISTRICT WAS RAZED IN 1940)

E.J. BELLOCQ'S PHOTOGRAPHS provide some of the ONLY PICTORAL EVIDENCE of this SHORT-LIVED but CULTURALLY SIG- NIFICANT DISTRICT (1897-1917). VICES LIKE DRINKING & PROSTITUTION WERE LEGAL WITHIN THE STORYVILLE BOUNDARIES, DRAWN UP BY POLITICIAN SIDNEY STORY (HENCE THE NAME).

LOUIS ARMSTRONG (NICKNAMES: SATCHMO & POPS) GREW UP POOR IN NEW ORLEANS, PLAYING ON STREET CORNERS FOR CHANGE. HE LEFT THE CITY IN 1922, AND OVER THE COURSE OF HIS LIFETIME HE BOTH HELPED DEFINE JAZZ AS A GENRE & SERVED AS ONE OF ITS PREEMINENT ICONS.

Louis Armstrong

1900 – 1971

BUFFA'S LOUNGE
RESTAURANT
AIR CONDITIONED

↰ submarine-like windows

we listen to live music in the back room & order the **BUFFA BURGER** + *sweet potato fries* ✳

✳ ALWAYS *sweet potato fries*

A FRIED CHICKEN SURVEY
in Treme:

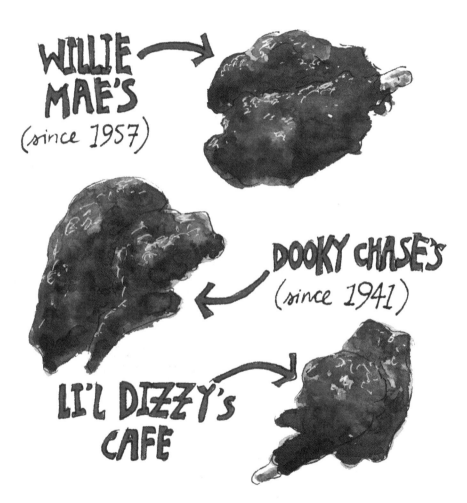

WILLIE MAE'S
(since 1957)

DOOKY CHASE'S
(since 1941)

LI'L DIZZY'S CAFE

since the nuances of fried chicken are impossible to express with paint on paper, it's best you try all 3 yourself.

magnificent mansions
ALONG ESPLANADE AVENUE

A GREAT EXAMPLE of QUEEN ANNE-STYLE ARCHITECTURE

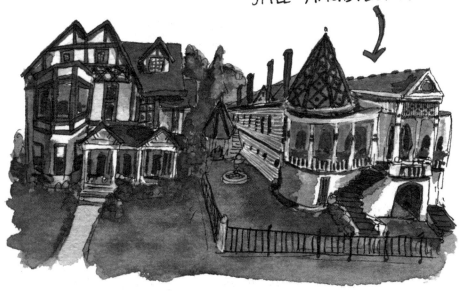

ESPLANADE AVE WAS A WEALTHY CREOLE CORRIDOR. THE SPECTACULAR ARCHITECTURE ATTESTS TO THE AVENUE'S HISTORIC WEALTH.

JULIUS WEISS, A GERMAN COTTON BROKER, BUILT THESE THREE HOUSES ALONG ESPLANADE AVENUE IN 1883. THEY WERE BUILT WITH CLASSIC SHOTGUN ELEMENTS — like external porch galleries instead of internal hallways — AS ONE-TO-TWO-FAMILY HOMES.

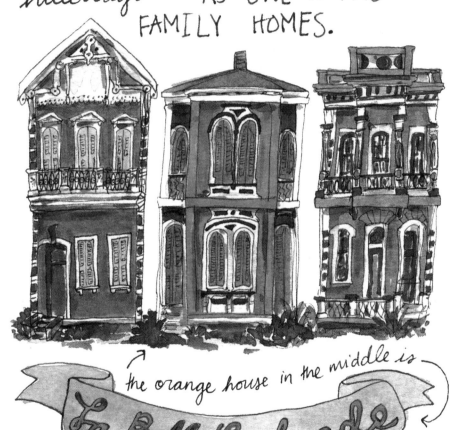

the orange house in the middle is

La Belle Esplanade

a lovely bed & breakfast whose owner is as colorful as the building's exterior.

THE OLD JOCKEY CLUB,

OR— *The Luling Mansion.*

BUILT IN **1865** BY THE LULING FAMILY, THE GROUNDS WERE ONCE EXTENSIVE. (80 ACRES!)

MR LULING SOLD HIS MANSION TO THE LOUISIANA JOCKEY CLUB IN **1871**. IT HELD EXTRAVAGANT RACETRACK-AFFILIATED FESTIVITIES UNTIL THE CLUB LEFT IN **1899**. NOW IT'S (POORLY-MAINTAINED) APARTMENTS.

FAIR GRINDS COFFEE

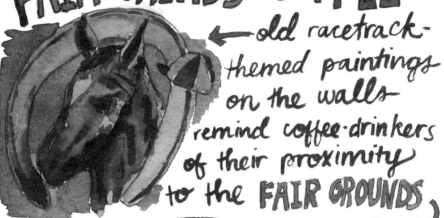

←— old racetrack-themed paintings on the walls remind coffee-drinkers of their proximity to the **FAIR GROUNDS**

MORNING REGULARS ENJOYING COFFEE & COMPANY

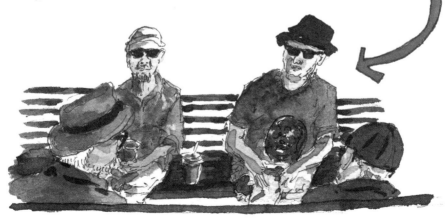

THE 7 PEOPLE YOU SEE AT JAZZ FEST

THE LOCALS

OL' FAITHFUL

SHOWS UP AT OPENING & LEAVES AT CLOSING

HASN'T MISSED JAZZ FEST FOR THE PAST 15 YEARS

COMES PREPARED WITH ALL THE RIGHT AMENITIES, PLUS HANDKERCHIEF FOR MOPPING UP SWEAT & WAVING IN SECOND LINES

WEARS A DIFFERENT SHIRT FROM THEIR VINTAGE BAYOU WEAR COLLECTION EACH DAY

②

THE PROFESSIONAL FESTIVAL MOMS & DADS

PHONE POISED TO CAPTURE CUTE SHOTS OF THEIR KIDS DANCING

WIDE-BRIMMED HATS, NOSES WHITE FROM SUNSCREEN

KNOWS WHERE TO FIND THE SHORTEST PORTA-POTTY LINES

PACKED PLENTY OF WATER (& SOMETHING STRONGER FOR THEMSELVES)

SNUCK IN SNACKS FOR THE KIDS

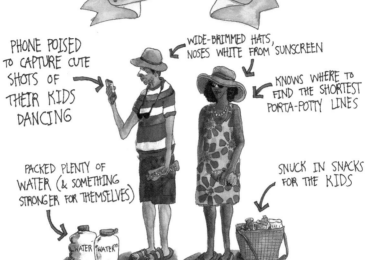

③

THE TEENY BOPPERS

LOTS OF FLAT-BILLED HATS, '60s & '70s-INSPIRED ATTIRE, NEON

WOULD RATHER BE AT COACHELLA

SEEN AT STAGES, NOT TENTS

ONLY SHOW UP FOR THE FINAL BIG-NAME SHOW

NEVER LISTENED TO ACTUAL JAZZ OR BLUES FOR MORE THAN 5 MINUTES

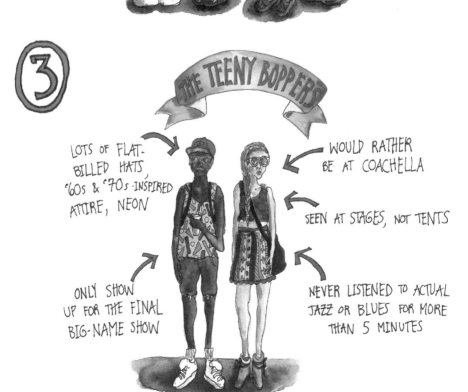

④

THE CHAIR BEARS

COME EQUIPPED WITH CHAIRS, UMBRELLAS & MYRIAD COMFORT AMENITIES

LARGE STRAWBERRY LEMONADES OR ICED TEAS IN HAND

OFTEN SEEN AT THE ACURA STAGE

OCCASIONALLY STAND UP TO DANCE DIRECTLY IN FRONT OF CHAIR

VARIETY OF BATTERY-POWERED MISTERS, FANS, ETC.

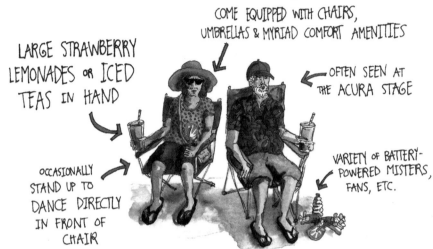

⑤

THE CHARACTERS

HULA HOOP GIRL

THE ECCENTRIC

EUPHORIC EXPRESSION

BANGLE BRACELETS

CROP TOP

WILD HAT: OFTEN THE PIÈCE DE RÉSISTANCE

MAXI SKIRT

ALWAYS MOVING & DANCING

BAREFOOT

USUALLY ATTENDS ALONE, CONTRIBUTING TO GENERAL AURA OF INTRIGUE

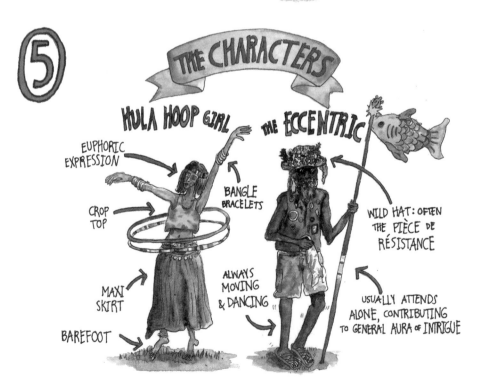

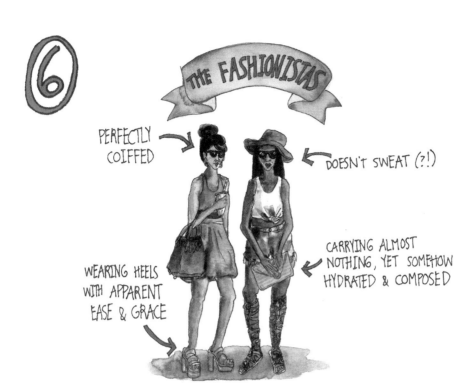

⑥ THE FASHIONISTAS

PERFECTLY COIFFED

DOESN'T SWEAT (?!)

CARRYING ALMOST NOTHING, YET SOMEHOW HYDRATED & COMPOSED

WEARING HEELS WITH APPARENT EASE & GRACE

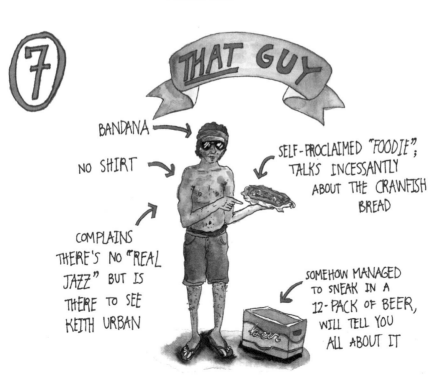

⑦ THAT GUY

BANDANA

NO SHIRT

SELF-PROCLAIMED "FOODIE"; TALKS INCESSANTLY ABOUT THE CRAWFISH BREAD

COMPLAINS THERE'S NO "REAL JAZZ" BUT IS THERE TO SEE KEITH URBAN

SOMEHOW MANAGED TO SNEAK IN A 12-PACK OF BEER, WILL TELL YOU ALL ABOUT IT

beer

127

MOST PEOPLE KNOW THE **FAIR GROUNDS RACE COURSE** SOLELY IN THE CONTEXT OF **JAZZ FEST,** WHEN THE GROUNDS ARE CONVERTED INTO A **MUSIC** AND **CULTURE EXTRAVAGANZA** FOR TWO WEEKS.

But most of the year, this track is for horse-racing & betting. The history of the Fair Grounds

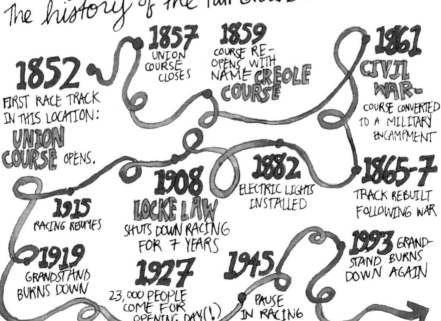

1852
FIRST RACE TRACK IN THIS LOCATION: **UNION COURSE** OPENS.

1857
UNION COURSE CLOSES

1859
COURSE RE-OPENS WITH NAME **CREOLE COURSE**

1861
CIVIL WAR-
COURSE CONVERTED TO A MILITARY ENCAMPMENT

1865-7
TRACK REBUILT FOLLOWING WAR

1882
ELECTRIC LIGHTS INSTALLED

1908
LOCKE LAW
SHUTS DOWN RACING FOR 7 YEARS

1915
RACING RESUMES

1919
GRANDSTAND BURNS DOWN

1927
23,000 PEOPLE COME FOR OPENING DAY (!)

1945
PAUSE IN RACING DUE TO WWII

1993 GRAND-STAND BURNS DOWN AGAIN

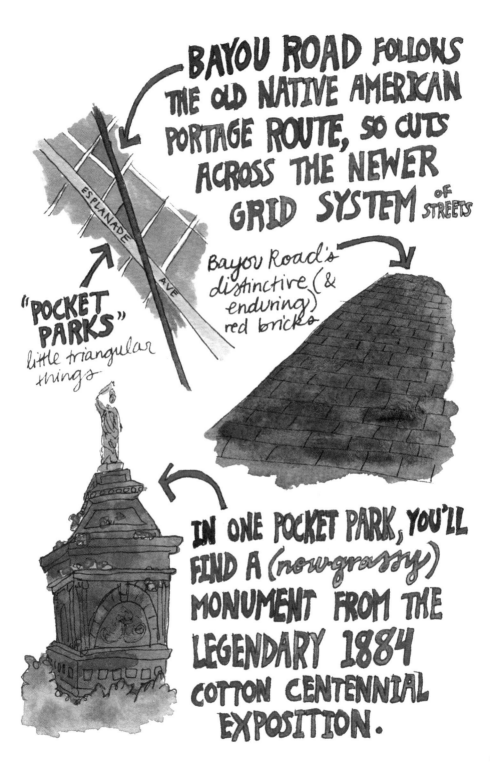

BAYOU ROAD FOLLOWS THE OLD NATIVE AMERICAN PORTAGE ROUTE, SO CUTS ACROSS THE NEWER GRID SYSTEM OF STREETS

Bayou Road's distinctive (& enduring) red bricks

"POCKET PARKS" little triangular things

IN ONE POCKET PARK, YOU'LL FIND A (now grassy) MONUMENT FROM THE LEGENDARY 1884 COTTON CENTENNIAL EXPOSITION.

129

"Police Jail & Patrol Station"

BUILT IN 1902. BECAME A COMMUNITY CENTER & LIBRARY IN 1951.

Queen Anne & French Renaissance Revival style building — to me the whimsy seems incongruous with the building's original function!

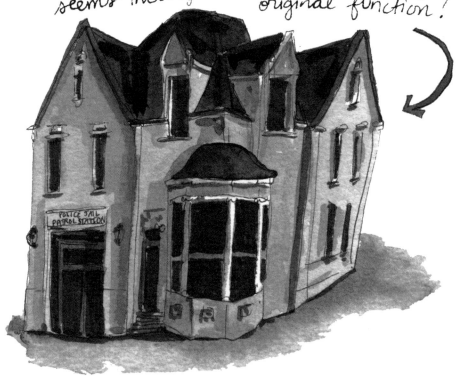

POLICE JAIL PATROL STATION

badly damaged by Hurricane Katrina in 2005, it was marked as one of the "most endangered historical sites" in 2010 by the Louisiana Landmark Society. It was recently bought & renovated.

Pagoda Café

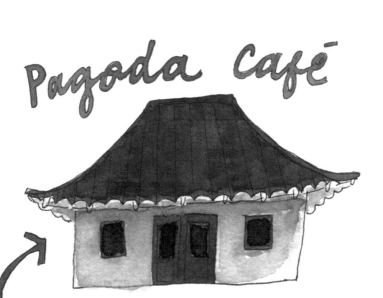

THE STRUCTURE WAS ORIGINALLY A DROP-OFF POINT FOR THE POPULAR 1930s LAUNDRY CHAIN CALLED ORIENTAL LAUNDRY, OWNED BY A CHINESE FAMILY. NOW IT'S A CHARMING SPOT TO GET LUNCH & COFFEE. If you <u>do</u> need your laundry done, travel a little ways down Esplanade Ave to the laundromat currently serving the area

Splish Splash Washateria

Splish Splash WASHATERIA

Bernard Xavier Philippe de Marigny de Mandeville ~

OR, JUST BERNARD DE MARIGNY.

THE MAN WAS **VERY RICH** AND **LOVED TO GAMBLE** — CRAPS WAS HIS FAVORITE.

HE OWNED LOTS OF LAND, INCLUDING the Marigny Plantation. AFTER LOSING MUCH OF HIS INHERITED FORTUNE TO GAMBLING, HE DIVIDED THE PLANTATION INTO SMALLER, RESIDENCE-SIZED PLOTS AND SOLD THEM OFF (YEAR: 1806-7). *FAUBOURG MARIGNY* — TODAY, JUST "THE MARIGNY" — WAS BORN.

Marigny (THE MAN) is famous for the **IMAGINATIVE** way he named streets in Faubourg Marigny (THE NEIGHBORHOOD).

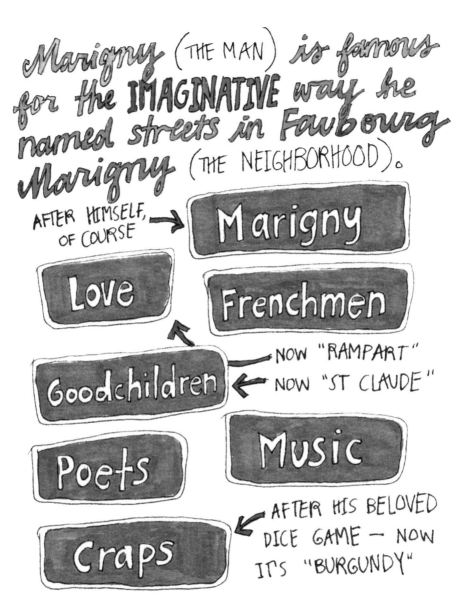

AFTER HIMSELF, OF COURSE →

Marigny

Love

Frenchmen

Goodchildren → NOW "RAMPART"
← NOW "ST CLAUDE"

Poets

Music

Craps ← AFTER HIS BELOVED DICE GAME — NOW IT'S "BURGUNDY"

NAMED FOR THE CHAMPS ELYSEE IN PARIS. (A BIT OF A STRETCH, I'D SAY, BUT I GUESS THE MAN WAS OPTIMISTIC) → **Elysian Fields**

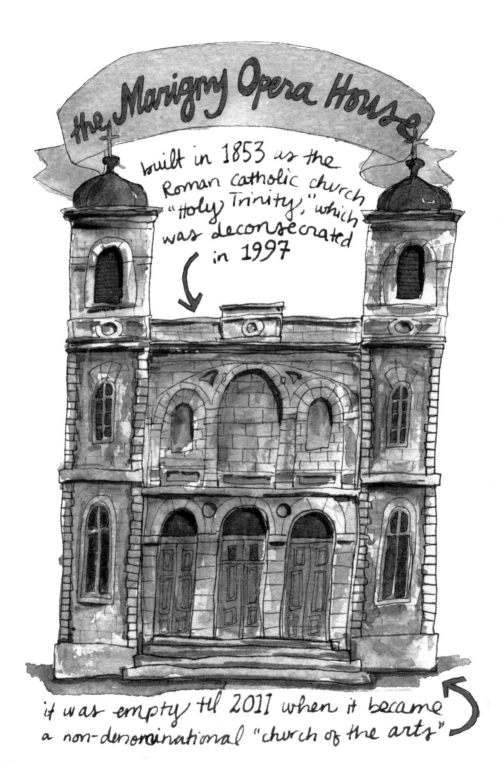

the Marigny Opera House

built in 1853 as the Roman catholic church "Holy Trinity," which was deconsecrated in 1997

it was empty til 2011 when it became a non-denominational "church of the arts"

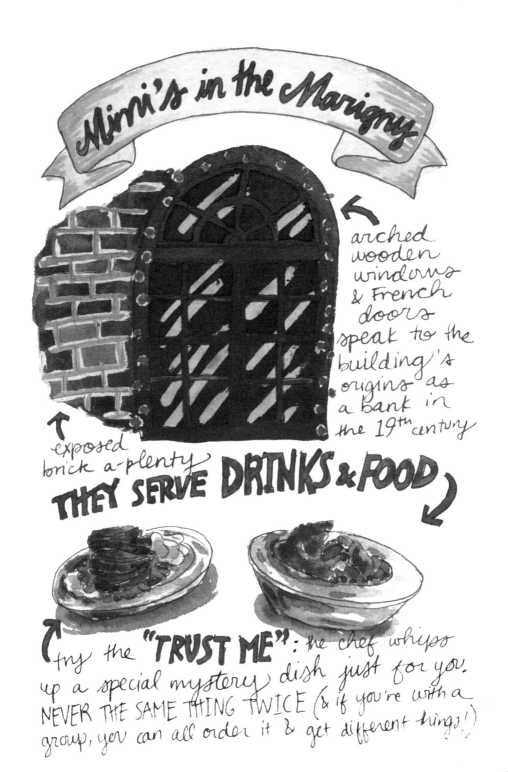

Mimi's in the Marigny

arched wooden windows & French doors speak to the building's origins as a bank in the 19th century

exposed brick a-plenty

THEY SERVE DRINKS & FOOD

try the **"TRUST ME"**: the chef whips up a special mystery dish just for you. NEVER THE SAME THING TWICE (& if you're with a group, you can all order it & get different things!)

135

A MELLOW MARIGNY BAR, GOOD FOR CATCHING UP ON ALL THE LOCAL GOSSIP. MARC, THE OWNER, GOT THE BAR FROM HIS COLORFUL FATHER — "BORDERLINE FAMOUS AT HARRAH'S CASINO," MARC SAYS.

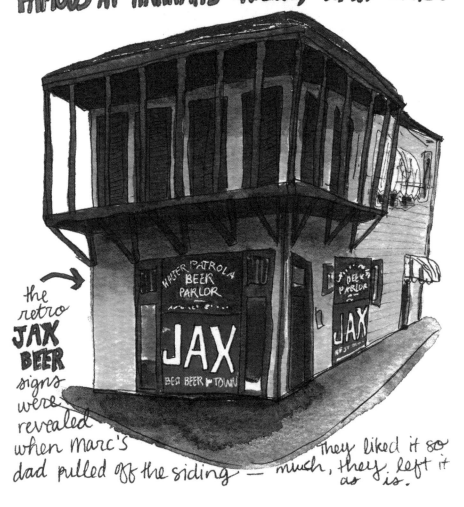

the retro **JAX BEER** signs were revealed when marc's dad pulled off the siding — they liked it so much, they left it as is.

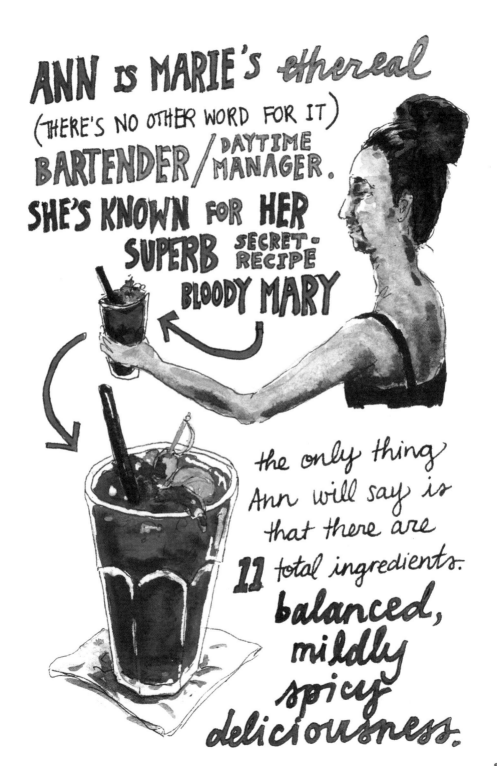

ANN IS MARIE'S *ethereal*
(THERE'S NO OTHER WORD FOR IT)
BARTENDER / DAYTIME MANAGER.
SHE'S KNOWN FOR HER SUPERB SECRET-RECIPE BLOODY MARY

the only thing Ann will say is that there are **11** total ingredients. **balanced, mildly spicy deliciousness.**

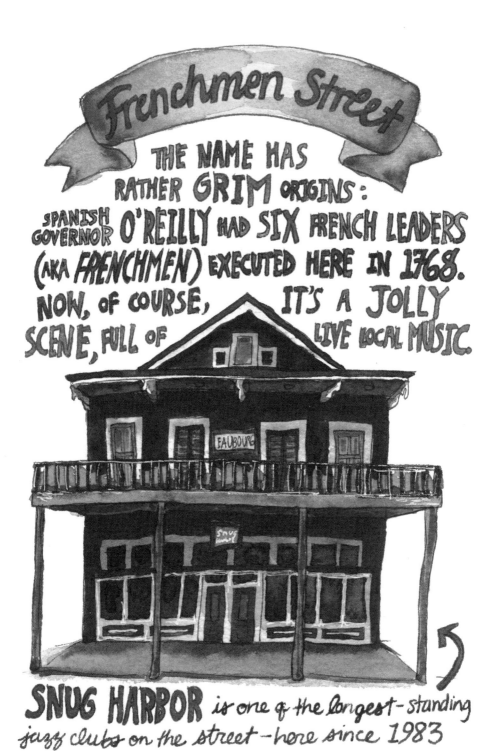

Frenchmen Street

THE NAME HAS RATHER GRIM ORIGINS: SPANISH GOVERNOR O'REILLY HAD SIX FRENCH LEADERS (AKA *FRENCHMEN*) EXECUTED HERE IN 1768. NOW, OF COURSE, IT'S A JOLLY SCENE, FULL OF LIVE LOCAL MUSIC.

FAUBOURG

SNUG HARBOR is one of the longest-standing jazz clubs on the street — here since 1983

art for sale beneath twinkling lights on Frenchmen street. LISTEN TO LIVE MUSIC! BUY LOCAL ART! A PERFECT PAIRING.

NOTE: I AM DECIDEDLY BIASED IN THIS AREA: SINCE I SELL MY WORK HERE IN THE **ART GARDEN,** I'M QUITE PARTIAL IN MY RECOMMENDATION!

ST. CLAUDE AVE

a longtime COMMERCIAL CORRIDOR — *now it's a* NIGHTLIFE CORRIDOR, *too:*

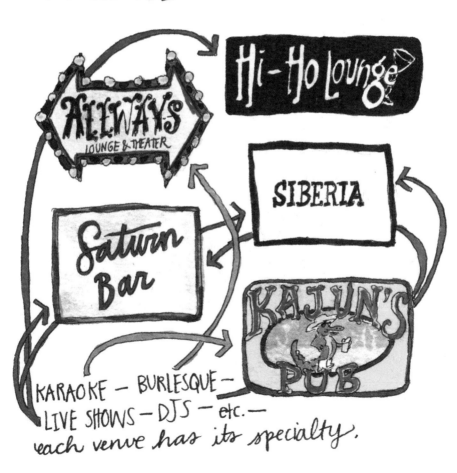

KARAOKE — BURLESQUE — LIVE SHOWS — DJS — etc. — *each venue has its specialty.*

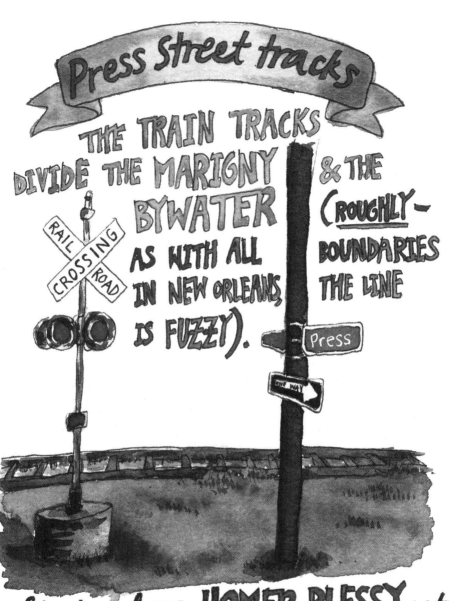

Press Street tracks

THE TRAIN TRACKS DIVIDE THE MARIGNY & THE BYWATER (ROUGHLY— AS WITH ALL BOUNDARIES IN NEW ORLEANS, THE LINE IS FUZZY).

RAIL ROAD CROSSING

Press

ONE WAY

This is where **HOMER PLESSY** sat in a "WHITES ONLY" train car in **1892** which prompted the landmark supreme court case **PLESSY vs FERGUSON.** THIS RESULTED IN THE OPPRESSIVE "SEPARATE but EQUAL" RULING.

141

HANK'S SUPER MARKET
FRIED CHICKEN HOT FOOD PO-BOYS SEA FOOD DAILY

along St Claude. Renowned for its
99¢ FRIED CHICKEN & FISH

← NO ONE REALLY KNOWS HOW IT CAN BE **SO CHEAP** – PROBABLY BETTER NOT TO ASK.

2 PC DARK	2 PC FISH	CHICKEN STRIPS
.99¢	.99¢	2 for $1.99

← greasy paper bags + fingers

OPEN 24 HOURS. POPULAR
LATE-NIGHT PIT STOP.

BYWATER BRUNCH HOTSPOTS

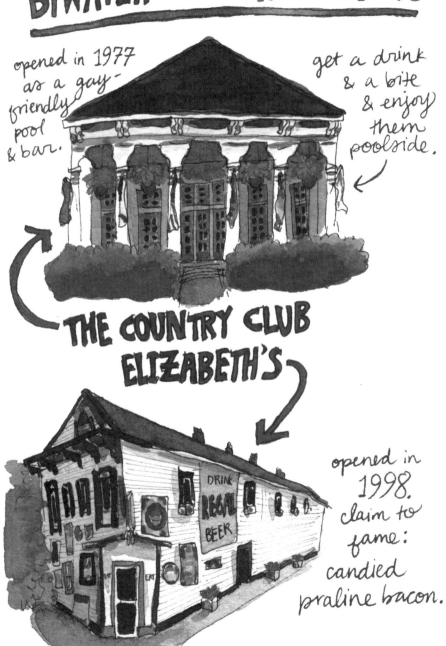

opened in 1977 as a gay-friendly pool & bar.

get a drink & a bite & enjoy them poolside.

THE COUNTRY CLUB
ELIZABETH'S

DRINK REGAL BEER

EAT

opened in 1998. claim to fame: candied praline bacon.

VAUGHAN's LOUNGE

CINDY, THE OWNER OF VAUGHAN'S, TRAVELS FREQUENTLY TO MEXICO, & ORDERED THESE CUSTOM-MADE FLAGS THERE. TURNED OUT THERE WAS A TYPO: "**LOONGE**" INSTEAD OF "**LOUNGE.**" CINDY LIKED IT SO MUCH SHE KEPT IT. So sit back & savor your cheap beers beneath festive "loonge" flags.

"THE NEIGHBORHOOD HATED TREES FOR A WHILE — IN THE '70's & '80s THE NEIGHBORHOOD ASSOCIATION WANTED TO PLANT SOME, BUT RESIDENTS COMPLAINED THAT TREES MAKE A MESS. SO I GOT OUT A JACK-HAMMER & PLANTED → SOME CYPRESS TREES IN FRONT OF MY HOUSE, TAKING A CUE FROM CINDY WHO'D ALREADY PLANTED SOME IN FRONT OF VAUGHAN'S LOUNGE. NOW PEOPLE LIKE THE SHADE."

← KEITH, ROGUE CYPRESS TREE PLANTER, MOVED HERE TO THE 9TH WARD (FROM ALGIERS) IN 1984.

145

bacchanal

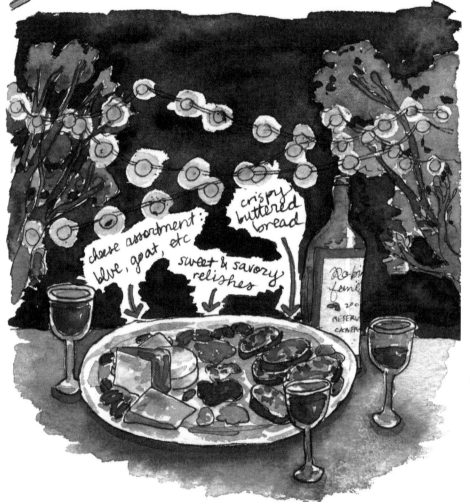

crispy buttered bread

cheese assortment: blue, goat, etc

sweet & savory relishes

Robi fami 200 RESERV CABER

WINE & CHEESE BENEATH A CANOPY OF TREES & LIGHTS — SURROUNDED BY CHATTER & LIVE MUSIC.

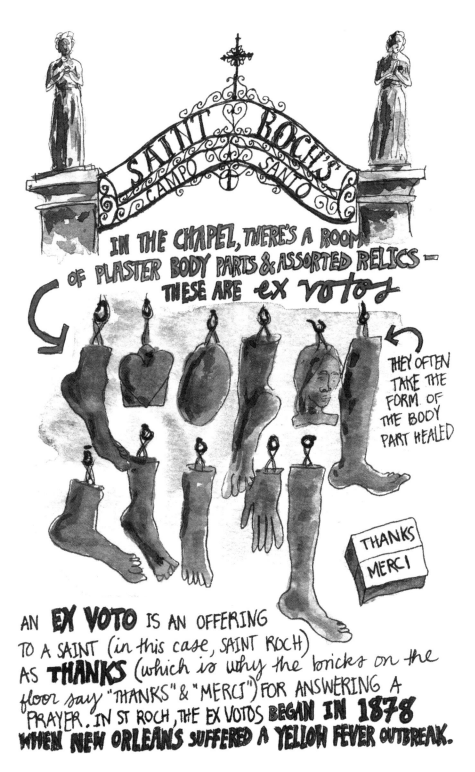

SAINT ROCH'S
CAMPO SANTO

IN THE CHAPEL, THERE'S A ROOM OF PLASTER BODY PARTS & ASSORTED RELICS — THESE ARE *ex votos*

THEY OFTEN TAKE THE FORM OF THE BODY PART HEALED

THANKS
MERCI

AN **EX VOTO** IS AN OFFERING TO A SAINT (in this case, SAINT ROCH) AS **THANKS** (which is why the bricks on the floor say "THANKS" & "MERCI") FOR ANSWERING A PRAYER. IN ST ROCH, THE EX VOTOS BEGAN **IN 1878** WHEN **NEW ORLEANS** SUFFERED A **YELLOW FEVER OUTBREAK.**

THE NOW-DEFUNCT HOLY CROSS SCHOOL BUILDING. THE HISTORY IS TOO COMPLEX FOR THIS PAGE — (INCLUDES 89 MILLION DOLLARS OF FEMA MONEY, IF THAT'S ANY INDICATION) — BUT THE RESULT IS THIS CRUMBLING SITE, ACCOMPANIED BY PLENTY OF FRUSTRATION & RESENTMENT FROM HOLY CROSS RESIDENTS.

blue tarp on the roof →

the school gave the neighborhood its name

↑ graffiti, general disrepair

SURROUNDED BY BEAUTIFUL, GIANT OAK TREES.

a few of the many churches

ST MAURICE

now deconsecrated — but still architect — urally impressive

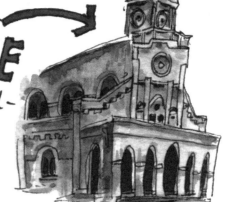

GREATER LITTLE ZION BAPTIST CHURH

sign reads "WE'VE COME THIS FAR BY FAITH — CELEBRATING 100 YEARS 1900-2000"

REAPING THE HARVEST

THE LEVEE SERVES AS BOTH A BOUNDARY (GEOGRAPHICALLY, VISUALLY) AND A PLACE FOR RECREATION.

when the boats float by, you can only see the tippy-top from afar — I find it very funny!

levee

DEAD END

HOLY CROSS RESIDENTS ARE VERY PROUD OF THEIR VIEW OF THE CITY SKYLINE

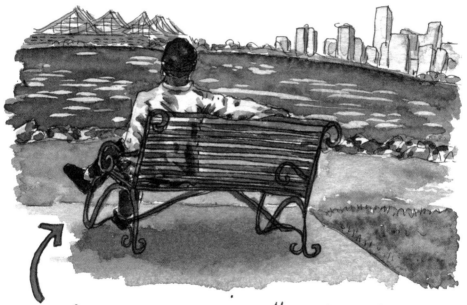

Calvin, sitting in the same spot on the levee where he would write term papers when he was a student at UNO in the 1980s

ALL SOULS
EPISCOPAL CHURCH & COMMUNITY CENTER

NICKNAMES LIKE *Saint Walgreens* & *The Walgreens Church* REFER TO THE BUILDING'S ORIGINAL FUNCTION: AS A DRUGSTORE

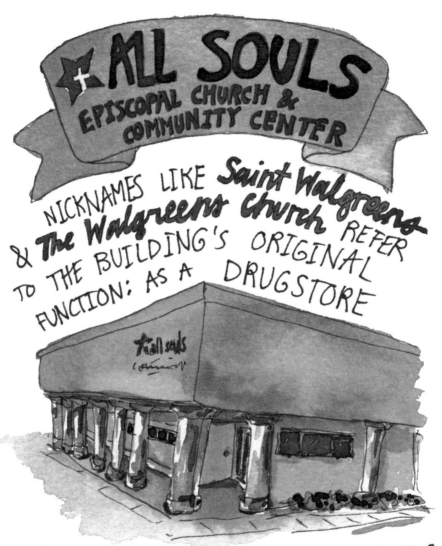

All Souls

THE STORY GOES: AFTER HURRICANE KATRINA, NEIGHBORS CONGREGATED HERE FOR SUPPLIES. IT BECAME A CENTER OF ACTIVISM. IN 2007, WALGREENS AGREED TO LEASE THE BUILDING TO ALL SOULS FOR A SYMBOLIC $2 PER YEAR FOR 10 YEARS. IT'S BEEN A COMMUNITY PILLAR EVER SINCE.

ALL SOULS' after-school program is only $1 per day; about **30** students take advantage of the diverse programming each afternoon.

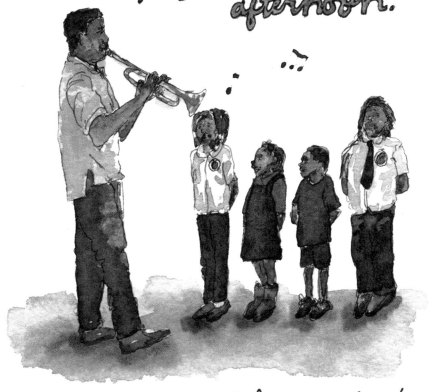

director Happy Johnson leads some chorus songs on trumpet

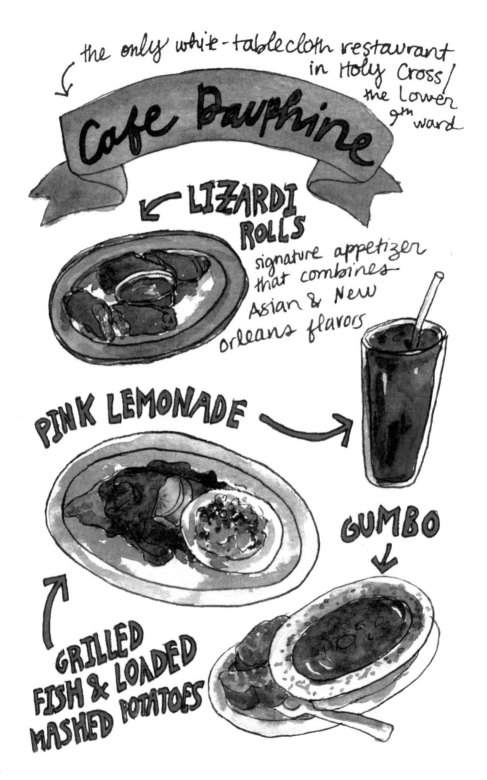

the only white-tablecloth restaurant in Holy Cross/ the Lower 9th ward

Cafe Dauphine

LIZARDI ROLLS

signature appetizer that combines Asian & New Orleans flavors

PINK LEMONADE

GUMBO

GRILLED FISH & LOADED MASHED POTATOES

the River Boat Captain's House

THE FIRST OF THE TWO IDENTICAL HOUSES WAS BUILT BY CAPTAIN MILTON DOULLUT IN 1905. THE SECOND WAS BUILT FOR HIS SON PAUL.

the river is right past this levee

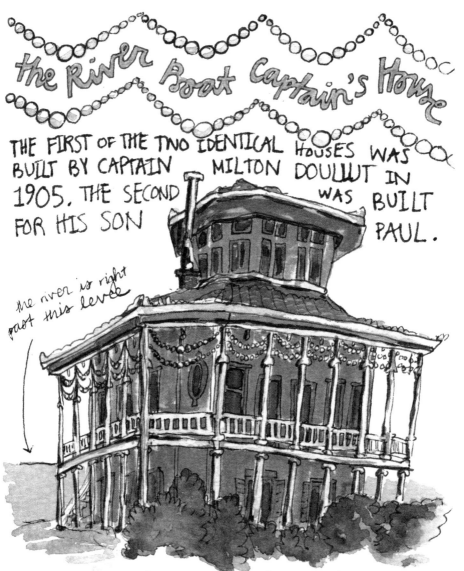

whimsy! intrigue! the houses' architecture was inspired by the steamboats that Captain Doullut spent his life steering up & down the Mississippi River.

JOHN TAYLOR, WETLAND SPECIALIST, ON HIS PORCH CARVING A WALKING STICK. HE MOVED HERE TO HOLY CROSS AFTER KATRINA.

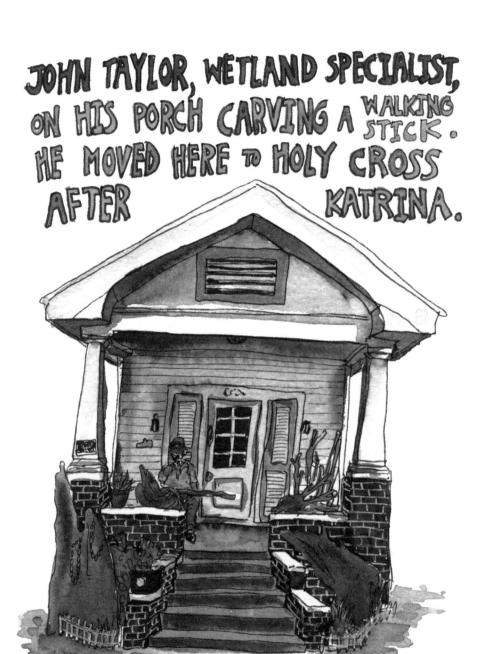

HE GREW UP AS ONE OF **11** KIDS ON THE OTHER SIDE OF CLAIBORNE IN THE LOWER 9TH. EVEN AS A KID, HE WAS "*different*," OR "*a bit off*" BECAUSE HE LOVED & COLLECTED & STUDIED WOOD & ANIMALS.

FOUND OBJECT
COLLECTIONS

SOME OF
JOHN'S MANY
WALKING STICKS

I LIKE TO FIND THINGS & MAKE THEM INTO SOMETHING ELSE — STICKS & DRIFTWOOD ESPECIALLY ...I CARVE THESE WALKING STICKS TO PASS THE TIME

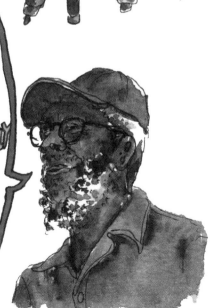

community gardens

SPECKLE THE NEIGHBORHOOD!

growing food is important because there are no grocery stores nearby & fresh food is difficult to access.

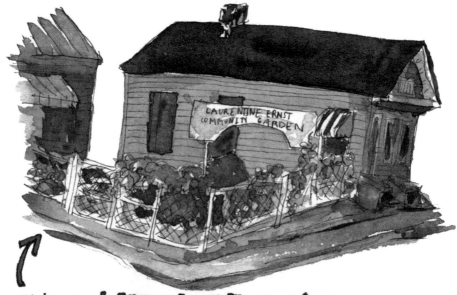

T this is **LAURENTINE ERNST** community garden. IT'S PART OF THE **BACKYARD GARDENERS NETWORK**, A NONPROFIT, DEVOTED TO "growing a stronger lower ninth ward" with food-growing traditions.

maria's magic house

BUILT IN **1899** AS A SINGLE·FAMILY HOME, BUT 6 YEARS LATER BECAME A SCHOOL FOR THE LUTHERAN MINISTRY. IT HAD BEEN EMPTY FOR OVER A DECADE WHEN MARIA BOUGHT IT IN 2013.

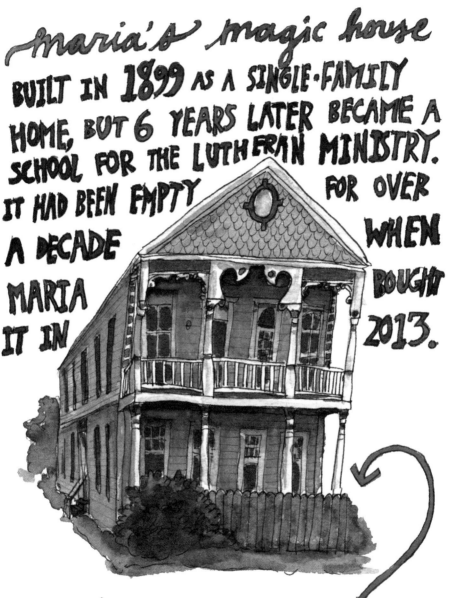

just behind this fence there are goats, chickens & cats — the big yard for animals was one of the main reasons maria fell in love with the house

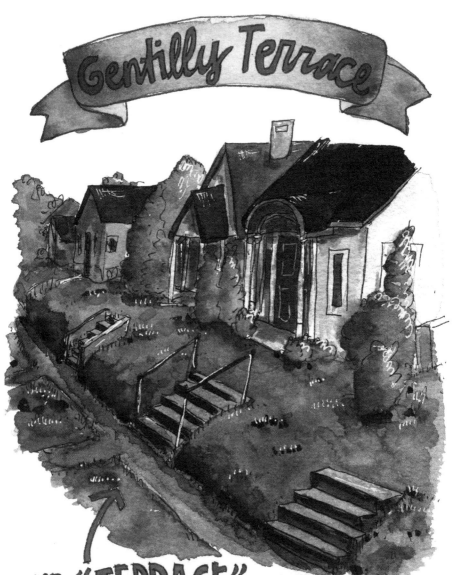

Gentilly Terrace

THE "TERRACE" BIT REFERS TO THE GROUND'S UPWARD SLOPE: HOUSES SIT ATOP MAN-MADE MOUNDS. HIGHER GROUND = SAFER FROM FLOODING.

gentilly lawn statues

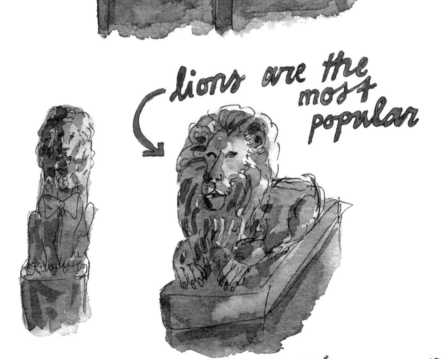

lions are the most popular

IN ADDITION TO THOSE RAISED, "TERRACED" PLOTS, GENTILLY FURTHERS ITS LAWN-CENTRIC IDENTITY WITH THESE OMNI-PRESENT DECORATIVE ANIMAL STATUES.

krewe of dreux

THIS OLD GAS STATION-TURNED-BAR-TURNED-ABANDONED-BUILDING-IS THE MEETING POINT FOR KREWE OF DREUX, A NEIGHBORHOOD CARNIVAL ORGANIZATION THAT PARADES THROUGH GENTILLY THE SUNDAY BEFORE MARDI GRAS DAY.

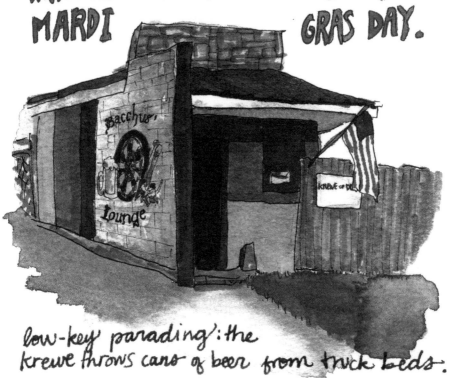

low-key parading: the krewe throws cans of beer from truck beds.

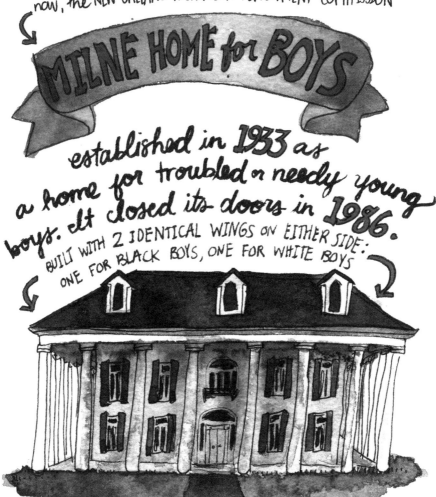

↳ now, the NEW ORLEANS RECREATION DEVELOPMENT COMMISSION

MILNE HOME for BOYS

established in 1933 as a home for troubled or needy young boys. It closed its doors in 1986.
BUILT WITH 2 IDENTICAL WINGS ON EITHER SIDE: ONE FOR BLACK BOYS, ONE FOR WHITE BOYS

LOUIS ARMSTRONG DID **NOT** ATTEND MILNE AS MANY BELIEVE — HE ACTUALLY ATTENDED **THE COLORED WAIFS' HOME FOR BOYS** (ON CITY PARK AVE) WHICH MERGED WITH MILNE IN **1932** (RIGHT AFTER, THIS LOCATION OPENED). ARMSTRONG WAS IN THE COLORED WAIFS' HOME FROM 1913-14.

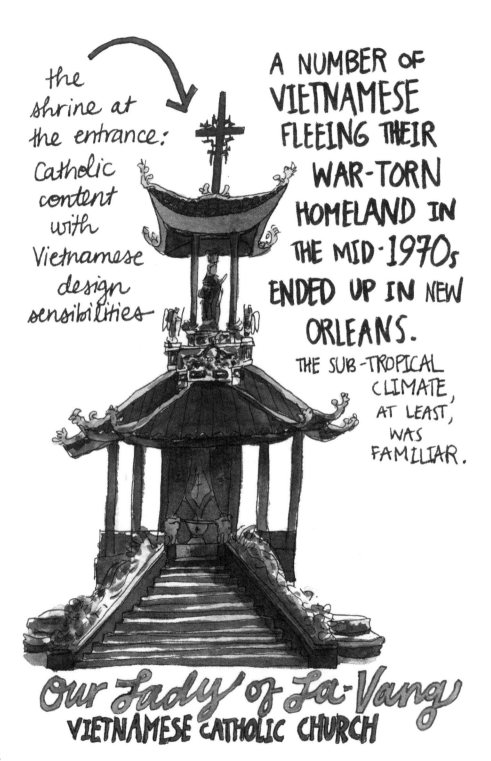

the shrine at the entrance: Catholic content with Vietnamese design sensibilities

A NUMBER OF VIETNAMESE FLEEING THEIR WAR-TORN HOMELAND IN THE MID-1970s ENDED UP IN NEW ORLEANS.

THE SUB-TROPICAL CLIMATE, AT LEAST, WAS FAMILIAR.

Our Lady of La-Vang VIETNAMESE CATHOLIC CHURCH

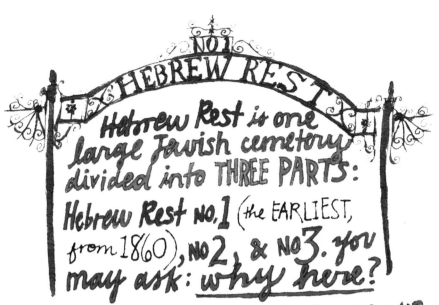

Hebrew Rest is one large Jewish cemetery divided into THREE PARTS: Hebrew Rest NO. 1 (the EARLIEST, from 1860), NO 2, & NO 3. you may ask: why here?

ACCORDING TO JEWISH TRADITION, THE DEAD MUST BE BURIED *IN THE EARTH.* BECAUSE OF THAT PESKY HIGH WATER TABLE, NEW ORLEANIAN JEWS HAD TO GET A BIT CREATIVE: FIRST, THEY BOUGHT THIS LAND IN GENTILLY RIDGE, FAMOUSLY ONE OF THE HIGHEST POINTS IN THE CITY. SECOND, THEY BUILT UP STONE-BORDERED PLOTS SO THEY WERE STILL IN THE EARTH BUT HIGHER UP & AWAY FROM THE WATER TABLE.

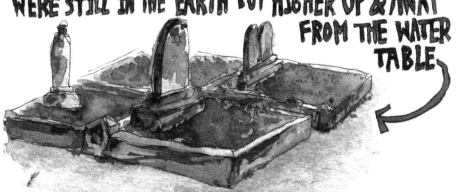

John Gendusa BAKERY

IN OPERATION SINCE THE 1920s

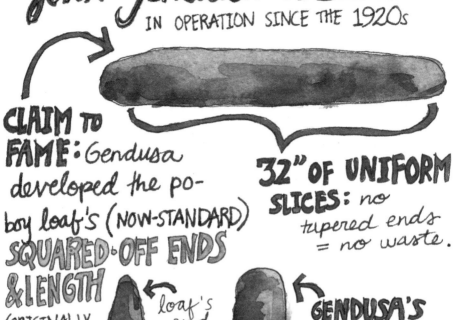

CLAIM TO FAME: Gendusa developed the po-boy loaf's (NOW-STANDARD) **SQUARED-OFF ENDS & LENGTH** (ORIGINALLY 40 INCHES, NOW 32).

32" OF UNIFORM SLICES: no tapered ends = no waste.

loaf's end **PRE-GENDUSA**

GENDUSA'S INNOVATION

RIGHT AROUND THE CORNER FROM THE **BAKERY, Zimmer's seafood** (HERE SINCE 1980) **USES GENDUSA'S LOAVES FOR ITS BELOVED SHRIMP POBOYS →**

THE ORIGINAL
NEW ORLEANS
SNO-BALLS
AND
SMOOTHEE

well-loved, (early)
long time (1990s)
Gentilly
establishment

open YEAR-ROUND ~ a feat for
the supplier of cold treats!

52 FLAVORS
(give or take)
TO CHOOSE FROM

MIX IT UP WITH A
cooler (ICE CREAM
BLENDED WITH A SNOBALL)
OR A stuffed
snoball (A SCOOP OF ICE
CREAM IN THE MIDDLE).

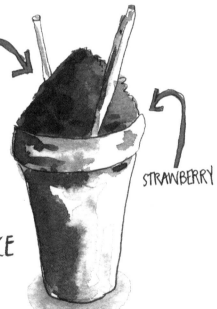

STRAWBERRY

they also serve up
nachos (a crowd favorite),
tamales, &
poboys

167

JUJU BAG CAFE IS ½ EATERY ½ BARBER SHOP. MS T RUNS THE CAFÉ SIDE & HER PARTNER MS PHYLLIS

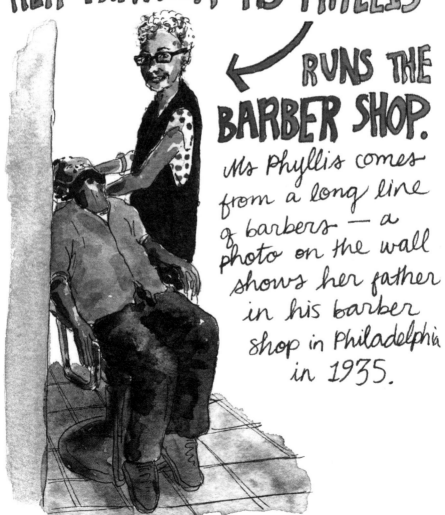

RUNS THE BARBER SHOP.

Ms Phyllis comes from a long line of barbers — a photo on the wall shows her father in his barber shop in Philadelphia in 1935.

JOHNNY'S HARDWARE

owned by JIMMY

JIMMY JOKED: "we're an old-fashioned hardware store — with 1900 service!"

"WE'RE A BAR WITHOUT ALCOHOL," Jimmy said, gesturing to the group of men gathered & chatting. "IT'S WHERE RETIREES COME TO SHOOT THE BREEZE."

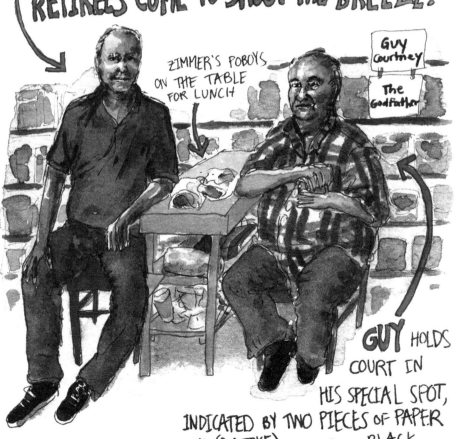

ZIMMER'S POBOYS ON THE TABLE FOR LUNCH

GUY Courtney

The Godfather

GUY HOLDS COURT IN HIS SPECIAL SPOT, INDICATED BY TWO PIECES OF PAPER WITH HIS NAME (& A JOKE NICKNAME) SCRAWLED IN BLACK MARKER.

169

IN A GREEN BOX OF A BUILDING,

McKenzie's CHICKEN-IN-A-BOX

THEY FRY CHICKEN & SERVE IT UP IN PAPER BOXES.

To get your chicken, you walk through an empty room — space that was once McKenzie's Bakery. THE BARREN DISPLAY CASES STILL STAND WHERE THEY DID IN 2000 WHEN ALL 54 OF THE McKENZIE'S STORES CLOSED.

bare shelves: a ghostly reminder of the once-ubiquitous local bakery

The (little-known) bomb shelter in Lakeview

(LAKEVIEW KIDS USED TO EXPLORE & PLAY INSIDE THE ABANDONED SHELTER BEFORE THE CITY BOARDED IT UP A FEW YEARS AGO)

LARGE (BARRED) METAL DOORS HERE

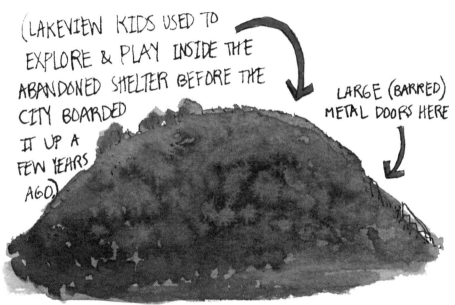

THIS "FALLOUT SHELTER" WAS BUILT IN 1962, AT THE HEIGHT OF THE COLD WAR HYSTERIA. CONSTRUCTED BY THE "OFFICE OF CIVIL DEFENSE," THIS ONCE STATE-OF-THE-ART, ENORMOUS UNDERGROUND FACILITY (IT COULD HOLD 1000s) IS NOW BARRED-SHUT, EERILY QUIET, & EASY TO MISS IF YOU'RE NOT LOOKING.

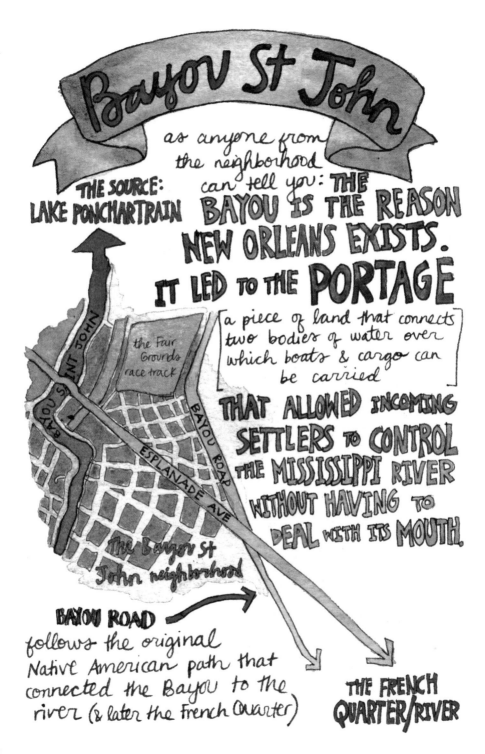

Bayou St John

as anyone from the neighborhood can tell you: **THE BAYOU IS THE REASON NEW ORLEANS EXISTS. IT LED TO THE PORTAGE**

THE SOURCE: LAKE PONCHARTRAIN

the Fair Grounds race track

BAYOU SAINT JOHN

ESPLANADE AVE

BAYOU ROAD

The Bayou St John neighborhood

[a piece of land that connects two bodies of water over which boats & cargo can be carried]

THAT ALLOWED INCOMING SETTLERS TO CONTROL THE MISSISSIPPI RIVER WITHOUT HAVING TO DEAL WITH ITS MOUTH.

BAYOU ROAD follows the original Native American path that connected the Bayou to the river (& later the French Quarter)

THE FRENCH QUARTER/RIVER

THE SPANISH FORT

(OR REMNANTS OF IT, ANYWAY)
THE FRENCH THEN SPANISH
USED IT FOR PROTECTION
IN THE 18TH CENTURY.
Then, from the 1820s
to 1920s, it became
an American amusement
park where wealthy New Orleanians
could escape the city.

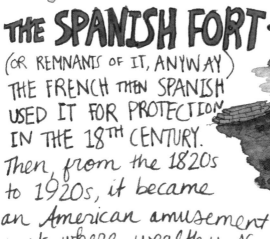

← THE OLDEST FIRE
HYDRANT IN THE CITY
(from 1869)

MAGNOLIA BRIDGE

BUILT IN 1896 — FLOATED ON A BARGE TO ITS CURRENT
LOCATION (IT USED TO BE AT ESPLANADE) IN 1909.
Today, it's pedestrian-only.

spectacular architecture
IN BAYOU ST JOHN

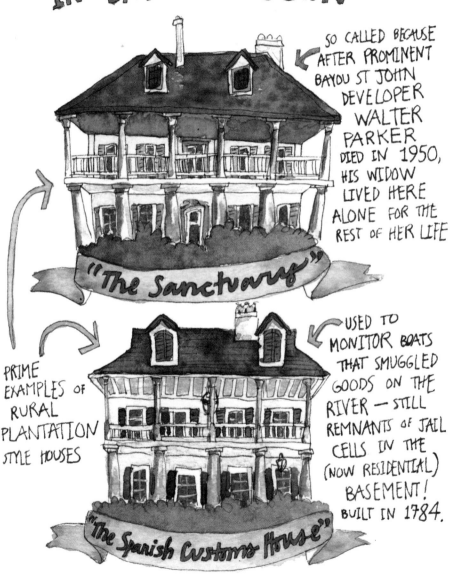

SO CALLED BECAUSE AFTER PROMINENT BAYOU ST JOHN DEVELOPER WALTER PARKER DIED IN 1950, HIS WIDOW LIVED HERE ALONE FOR THE REST OF HER LIFE

"The Sanctuary"

PRIME EXAMPLES OF RURAL PLANTATION STYLE HOUSES

USED TO MONITOR BOATS THAT SMUGGLED GOODS ON THE RIVER — STILL REMNANTS OF JAIL CELLS IN THE (NOW RESIDENTIAL) BASEMENT! BUILT IN 1784.

"The Spanish Customs House"

174

a most whimsical fence AT THE **DUFOUR-PLASSAN** HOUSE, BUILT IN **1870**. THE COMPANY THAT MADE THE FENCE (Wood, Miltenberger & Co.) IS ALSO RESPONSIBLE FOR TWO OTHER "CORNSTALK FENCES" IN THE CITY: ONE IN THE FRENCH QUARTER & ONE IN THE GARDEN DISTRICT.

fruit basket

corn stalk

sunflowers

pumpkins (or maybe squash)

OLDEST STEAKHOUSE IN NEW ORLEANS & ORIGINATOR OF THE *sizzling steak:*

plate is heated with butter; when the steak is served on it, there's dramatic sizzling, bubbling, popping & all!

cilantro garnish

THE RESTAURANT, CONSTRUCTED IN 1934 BY THE VOJKOVICH FAMILY (WHO STILL OWN IT), STILL BOASTS ITS ORIGINAL DÉCOR. *my favorite detail:* FOUR WOODEN BOOTHS IN WHICH DINERS CAN CLOSE THE CURTAINS FOR PRIVACY

I HAVE A SOFT SPOT FOR BUSINESSES PROUDLY PROCLAIMING 'AIR CONDITIONED' IN NEON TUBING. IT HARKENS BACK TO THOSE NOT-SO-LONG-AGO DAYS WHEN AIR CONDITIONING WAS A RARITY. THE SIGNS HAVE A NOSTALGIC FEEL — THOUGH I MUST ADMIT I DO _NOT_ LONG FOR A PRE-A.C. NEW ORLEANS.

Mandina's in Mid City, a local favorite since 1932. HOMESTYLE SEAFOOD & ITALIAN DISHES.

cannolis & coffee at
ANGELO BROCATO'S

crispy shell is stuffed
with ricotta (½ vanilla
& ½ chocolate)

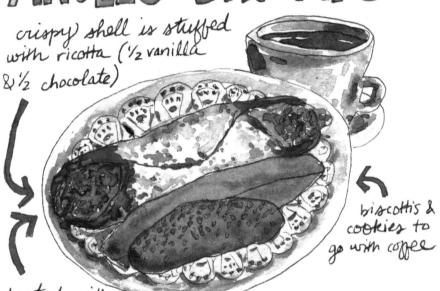

biscottis &
cookies to
go with coffee

dusted with
powdered sugar; ends are dipped in pistachio bits
(I have to admit: I can only manage one bite
of a cannoli before feeling a sugar overdose!)

BROCATO WAS PART OF A BIG WAVE OF
SICILIANS WHO IMMIGRATED TO NEW
ORLEANS IN THE LATE **19ᵀᴴ CENTURY.**

heart-backed chairs

SOME GO TO ANGELO BROCATO'S FOR GELATO or SPUMONI, BUT I GO FOR A COFFEE & AN ASSORTMENT OF CRISP, DUNK-ABLE TREATS

a daunting selection!

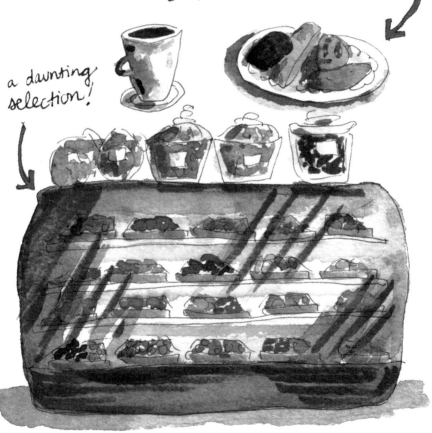

179

UPTOWN

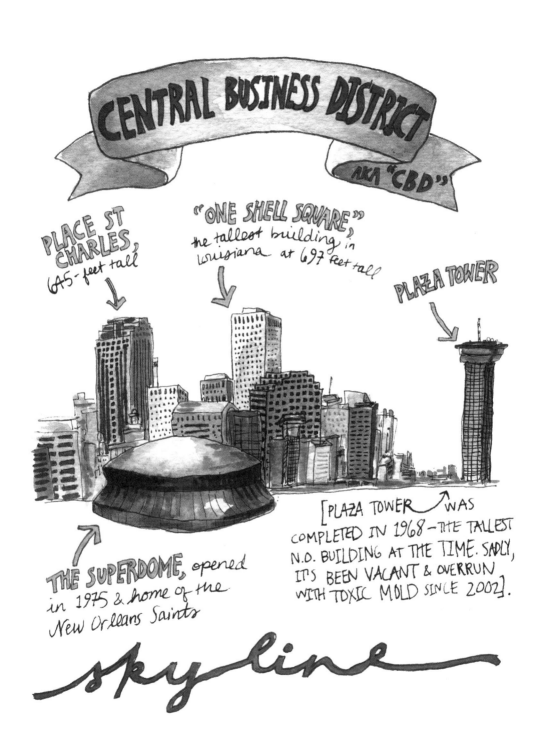

CENTRAL BUSINESS DISTRICT

AKA "CBD"

PLACE ST CHARLES, 645-feet tall

"ONE SHELL SQUARE", the tallest building in Louisiana at 697 feet tall

PLAZA TOWER

THE SUPERDOME, opened in 1975 & home of the New Orleans Saints

[PLAZA TOWER WAS COMPLETED IN 1968 — THE TALLEST N.O. BUILDING AT THE TIME. SADLY, IT'S BEEN VACANT & OVERRUN WITH TOXIC MOLD SINCE 2002].

skyline

MOTHER'S
WORLD'S BEST BAKED HAM
Restaurant
EST. 1938

← **FERDI SPECIAL**

ham, beef debris & cabbage — the cabbage soaks up the juice & still gives a crunch (lettuce would just wilt)

(ROAST BEEF **DEBRIS** IS THE STUFF SO SOFT & TENDER IT JUST FALLS APART)

FRIED SOFTSHELL CRAB POBOY

special butter sauce for the crab: butter, lemon juice, crystal, lea & perrins

CRAWFISH ETOUFFEE →

what the manager will recommend if you ask

PAT+SHIRLEY, "THE COOKING COUSINS."

they've been cooking at Mother's for 30 YEARS. their aunt, Odie Mae Peters, worked for the restaurant's original owner (the MAE'S GUMBO you see on the menu is named for her). Pat, shirley & their aunt Odie Mae all grew up in mississippi.

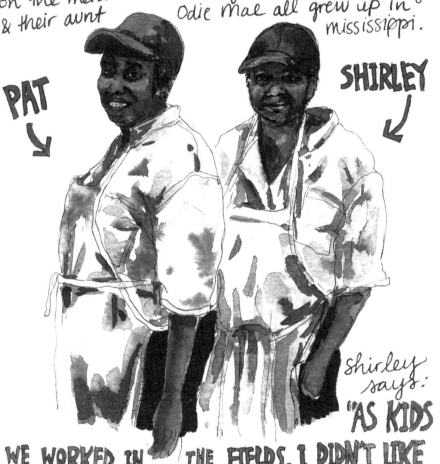

PAT

SHIRLEY

shirley says:

"AS KIDS WE WORKED IN THE FIELDS. I DIDN'T LIKE THAT—TOO MANY *BUGS*—SO I TRIED TO STAY INSIDE, IN THE KITCHEN. I MADE A HOMEMADE BISCUIT AT 12 THAT WOULD *MELT IN YOUR MOUTH*."

DUCK, BISCUIT-MAKER EXTRAORDINAIRE.

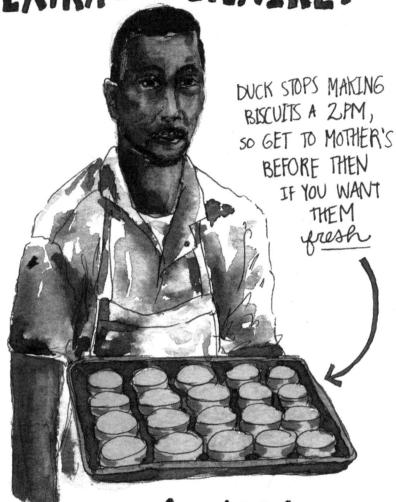

DUCK STOPS MAKING BISCUITS A 2 PM, SO GET TO MOTHER'S BEFORE THEN IF YOU WANT THEM *fresh*

he's been behind Mother's fresh, baked-daily biscuits for 25 YEARS. estimated production: 30-40 trays per day.

DUCK'S STEP-BY-STEP GUIDE TO BAKING BISCUITS:

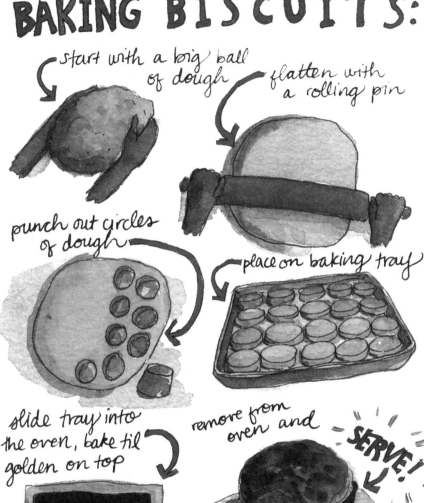

start with a big ball of dough

flatten with a rolling pin

punch out circles of dough

place on baking tray

slide tray into the oven, bake til golden on top

remove from oven and _SERVE!_

NOTE: THIS IS AFTER I LOADED IT WITH BUTTER & JAM & TOOK A (SCRUMPTIOUS) BITE.

built to encourage development in the then-derelict downtown area. meant to be the center of an Italian community/business area that never came to fruition, today it's squished between high-rises & parking garages & looks rather out of place.

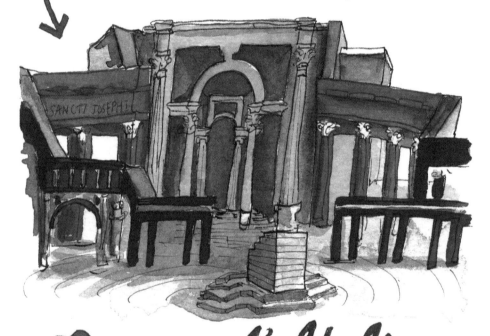

SANCTI JOSEPHI

Piazza d'Italia

DESIGNED BY CHARLES MOORE IN THE POSTMODERN STYLE. COMPLETED IN 1978. BRIGHT, CARTOONISH QUALITY.

A MEAL AT restaurant AUGUST
OWNED BY CELEBRATED LOUISIANA CHEF John Besh

sourdough + butter

a fancy egg
AMUSE-BOUCHE
(French for "mouth amuser";
a complimentary appetizer)

MUCH ATTENTION GIVEN TO
PRESENTATION:
AN OPENING FLOURISH, FINISHING TOUCHES

NOT ENOUGH SPACE TO DRAW ALL
THE DELIGHTFUL DISHES OR TO DESCRIBE THE
FLAVORS. SO LET THIS SUFFICE: yum.

JULIA ROW OF THE THIRTEEN SISTERS

the view from the back, via Camp Street. This architectural shape denotes a service wing, AKA slave quarters

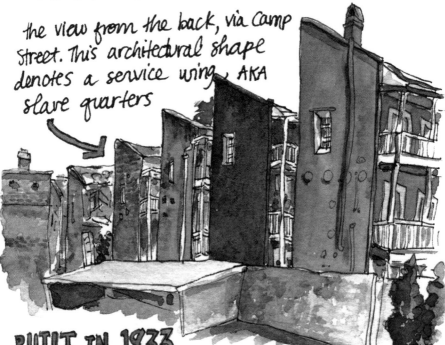

BUILT IN 1833, EACH SINGLE-FAMILY, 3-STORY HOME (OF WHICH THERE WERE THIRTEEN, ALL IN A ROW) HAD AN ATTACHED 3-STORY SERVICE WING. THE AREA'S EXTREME AFFLUENCE WANED FROM 1850-1870. IT TURNED INTO A BOARDING HOUSE. DECLINE CONTINUED UNTIL 1976 WHEN IT WAS BOUGHT & RESTORED.

the **OGDEN MUSEUM** OF **SOUTHERN ART**

← BENNY ANDREWS far & away my favorite artist in the collection. I love the soft Vermeer-esque luminosity contrasted with chunky textural collage elements in "GRANDMOTHER'S DINNER"

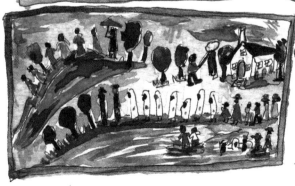

CLEMENTINE HUNTER, celebrated Louisiana folk artist

my favorite artists

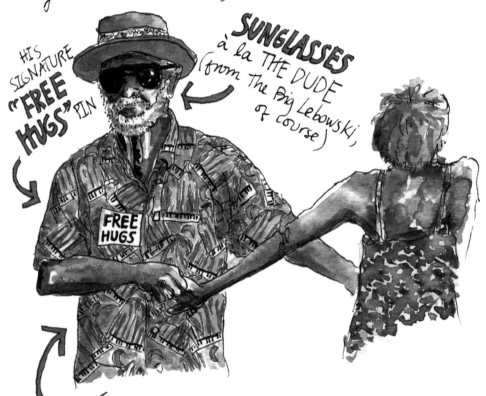

all the right moves
AT THE **BLUES & BBQ** FESTIVAL

one of the many New Orleans characters
you start to recognize around town

HIS SIGNATURE **"FREE HUGS"** PIN

SUNGLASSES à la THE DUDE (from The Big Lebowski, of course)

FREE HUGS

PIANO-PRINT JAZZ FEST SHIRT

WHEN HIS BODY MOVES, HIS FACE TAKES ON A KIND OF SERENE, ETHEREAL CALM.

Built in 1905; became the sole New Orleans power source in 1922. Shut down in 1973 and has been decaying ever since (sold to Market Street Properties in 2007 for $10 million, but soon after they went bankrupt).

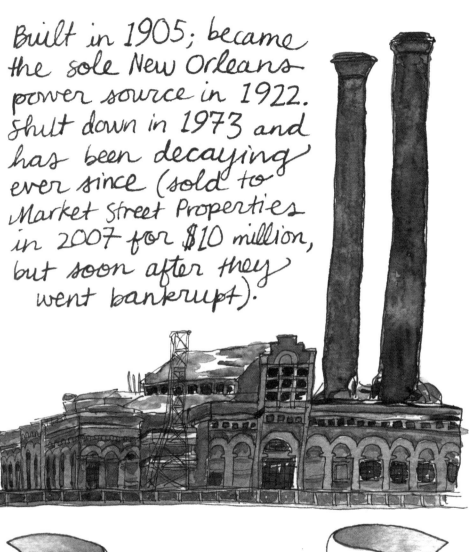

the MARKET STREET power plant

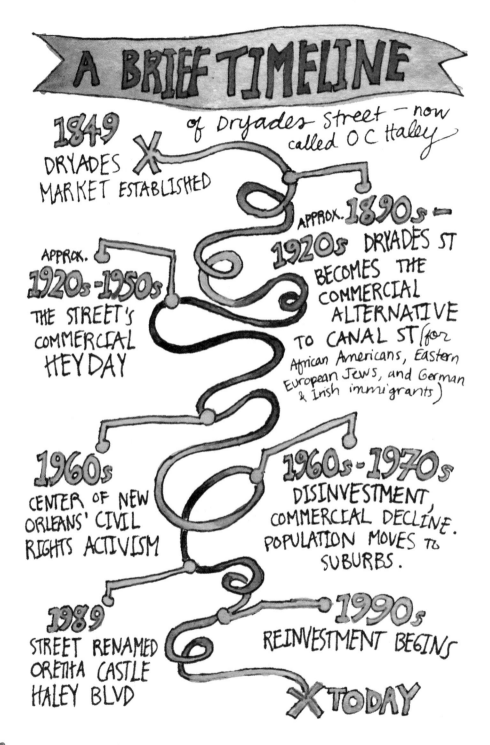

A BRIEF TIMELINE

of Dryades Street — now called O C Haley

1849 DRYADES MARKET ESTABLISHED

APPROX. 1890s - 1920s DRYADES ST BECOMES THE COMMERCIAL ALTERNATIVE TO CANAL ST (for African Americans, Eastern European Jews, and German & Irish immigrants)

APPROX. 1920s - 1950s THE STREET'S COMMERCIAL HEYDAY

1960s CENTER OF NEW ORLEANS' CIVIL RIGHTS ACTIVISM

1960s - 1970s DISINVESTMENT, COMMERCIAL DECLINE. POPULATION MOVES TO SUBURBS.

1989 STREET RENAMED ORETHA CASTLE HALEY BLVD

1990s REINVESTMENT BEGINS

TODAY

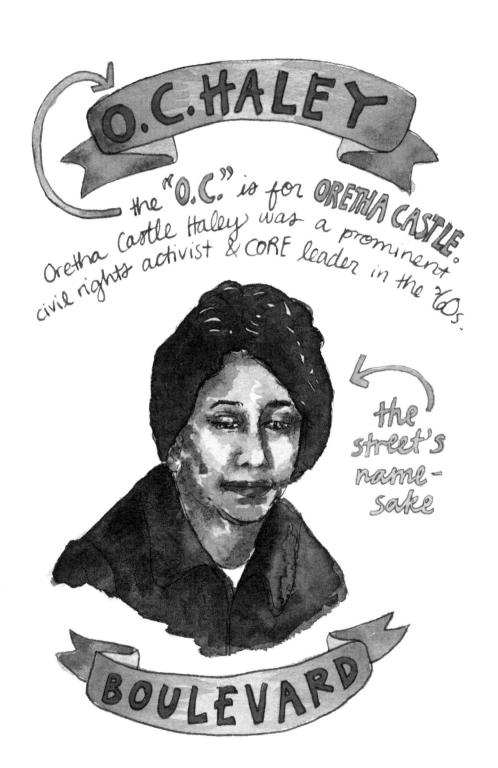

O.C. HALEY

the "O.C." is for ORETHA CASTLE.
Oretha Castle Haley was a prominent
civil rights activist & CORE leader in the '60s.

the street's name-sake

BOULEVARD

DRYADES WAS THE COMMERCIAL ALTERNATIVE TO CANAL STREET FOR AFRICAN AMERICANS & EASTERN EUROPEAN JEWS IN THE LATE 1800s & EARLY-MID 1900s. HANDELMAN'S DEPARTMENT STORE WAS ONE OF THE MOST PROMINENT JEWISH-OWNED BUSINESSES. IT CLOSED IN THE 1950s BUT THE SIGN REMAINS.

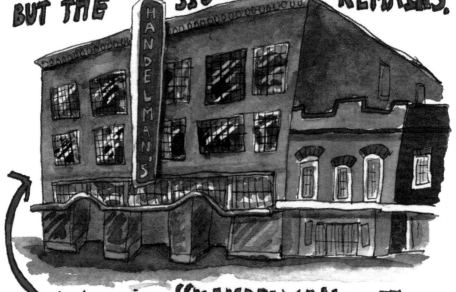

today, it's "HANDELMAN LOFT & MILLENIUM SQUARE APARTMENTS"

"the library"

THE DRYADES LIBRARY WAS BUILT IN 1915 AS THE FIRST LIBRARY FOR PEOPLE OF COLOR IN NEW ORLEANS. IT WAS DESEGREGATED IN 1955 & THRIVED UNTIL 1965 WHEN IT WAS BADLY DAMAGED IN HURRICANE BETSY. THE YMCA BOUGHT IT A FEW YEARS LATER.

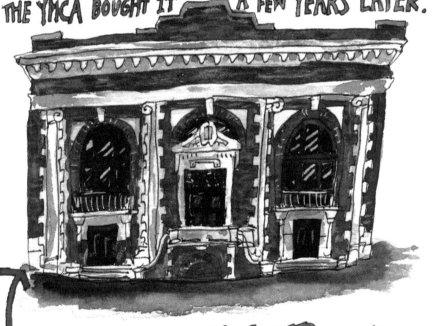

today it's a **DAYCARE CENTER** for the Dryades **YMCA**. people frequently call it by its old name, though: "the library."

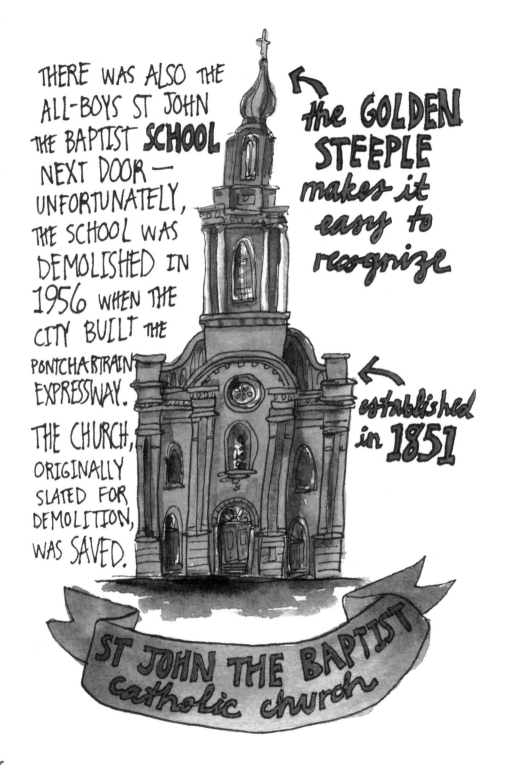

THERE WAS ALSO THE ALL-BOYS ST JOHN THE BAPTIST **SCHOOL** NEXT DOOR — UNFORTUNATELY, THE SCHOOL WAS DEMOLISHED IN 1956 WHEN THE CITY BUILT THE PONTCHARTRAIN EXPRESSWAY.

THE CHURCH, ORIGINALLY SLATED FOR DEMOLITION, WAS SAVED.

the **GOLDEN STEEPLE** makes it easy to recognize

established in **1851**

ST JOHN THE BAPTIST catholic church

the *Dryades* YMCA

established in **1905** by the *Colored Young Men's Christian Association*, it's been an integral community center ever since. The building was damaged by a fire in 2000 but was completely renovated to its current state-of-the-art facilities in 2005 (post-Katrina).

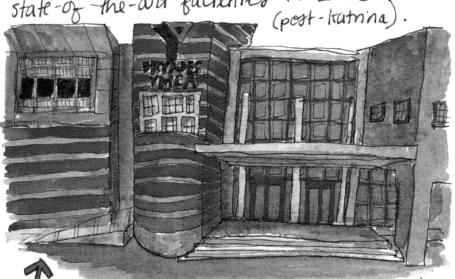

↑ unique as a YMCA because it's also home to the **JAMES M SINGLETON** charter school ↑

midnight basketball games in the gym — one of the most popular programs

LIVING WITNESS CHURCH of GOD IN CHRIST

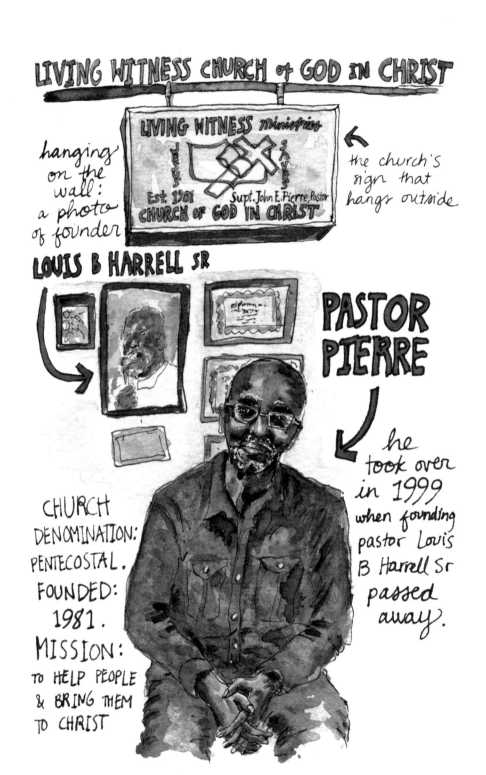

hanging on the wall: a photo of founder

the church's sign that hangs outside

LIVING WITNESS ministries

JESUS SAVES

Est. 1981 Supt. John E. Pierre, Pastor

CHURCH of GOD IN CHRIST

LOUIS B HARRELL SR

PASTOR PIERRE

he took over in 1999 when founding pastor Louis B Harrell Sr passed away.

CHURCH DENOMINATION: PENTECOSTAL. FOUNDED: 1981. MISSION: TO HELP PEOPLE & BRING THEM TO CHRIST

"we've been here since 1981 when the street was still called **DRYADES**. Things were pretty bad back then: ~~businesses~~ had closed, there was 'white flight' to the suburbs. **IT WAS A TIME OF STEEP ECONOMIC & SPIRITUAL DECLINE.** Pastor Harrell came in to help. WE USED TO SIT HERE & LOOK OUT THE CHURCH WINDOWS AT DRUG DEALS & PROSTITUTES. After church-goers had their cars vandalized in the '80s, we ~~took~~ the church out to the sidewalk — DRUMS, TAMBOURINES & ALL — the drug-dealers & prostitutes scattered like roaches when the lights come on! WE INVEST IN THE COMMUNITY WITH PROGRAMS LIKE **FEED THE HUNGRY** (started in '85) & THE **NEHEMIAH RESTORATION PROGRAM** (started in '94) — BOTH STILL GOING STRONG TODAY." ~ Pastor Pierre

LIVING WITNESS CHURCH of GOD IN CHRIST PT II

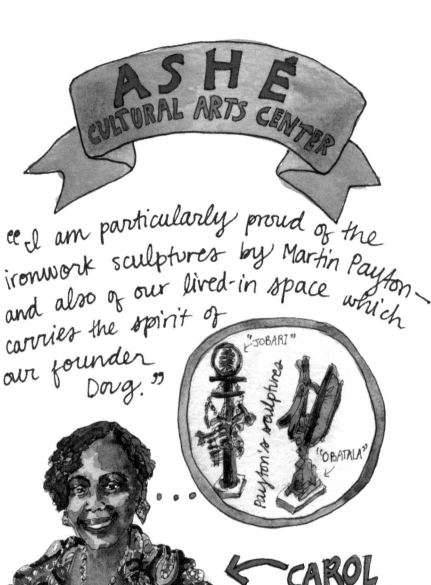

ASHÉ
CULTURAL ARTS CENTER

"I am particularly proud of the ironwork sculptures by Martin Payton— and also of our lived-in space which carries the spirit of our founder Doug."

"JOBARI"

Payton's sculptures

"OBATALA"

← CAROL BEBELLE, director & co-founder of Ashé

chairs lining the windows at Ashé:

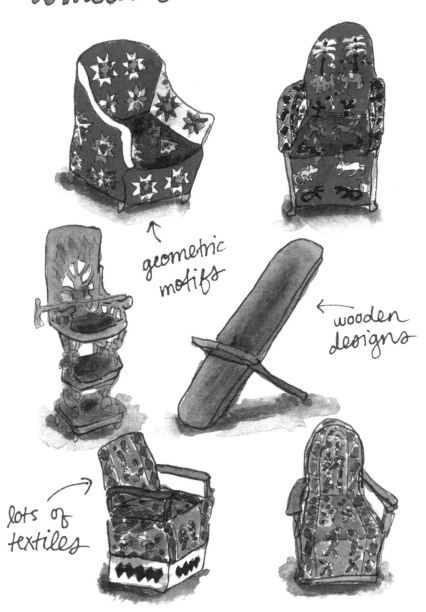

geometric motifs

wooden designs

lots of textiles

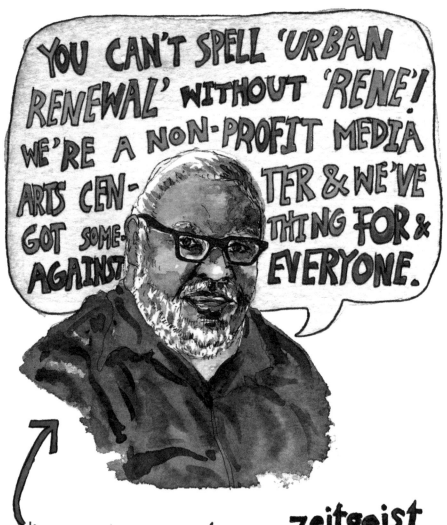

Rene, the founder of **zeitgeist**. Since its inception 29 years ago, it's been in quite a few locations, but it's "home" now on O.C. Haley where it's lived for the past 16 years.

A BLACK-AND-WHITE PHOTOGRAPH FROM 1943 SHOWS DRYADES MARKET IN ITS PRIME.

this side is where SoFAB is now

this side is now the **NEW ORLEANS JAZZ MARKET** — the name may pay homage to the past, but the building is utterly sleek & modern

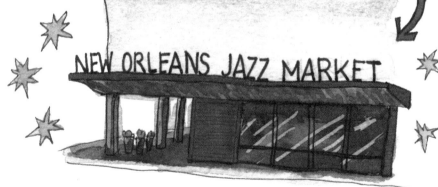

OPENED IN 2015 · OWNED & OPERATED BY THE NEW ORLEANS JAZZ ORCHESTRA. live music with no cover on Thursday, Friday & Saturday nights.

SoFAB

↑ ↑ ↑ ↑

Southern Food and Beverage

MUSEUM

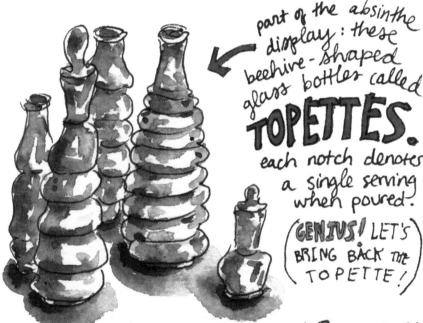

part of the absinthe display: these beehive-shaped glass bottles called **TOPETTES.** each notch denotes a single serving when poured.

(**GENIUS!** LET'S BRING BACK THE TOPETTE!)

CLAIMS TO FAME INCLUDE: HAVING THE LARGEST COLLECTION OF ARTIFACTS ABOUT ABSINTHE ON EXHIBIT and BEING THE ONLY NON-CORPORATE/NON-BRAND-RELATED FOOD MUSEUM IN THE U.S.

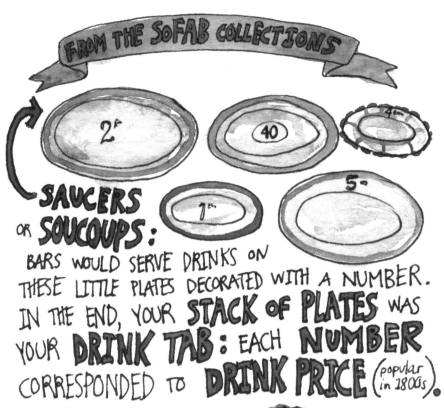

SAUCERS OR SOUCOUPS:

BARS WOULD SERVE DRINKS ON THESE LITTLE PLATES DECORATED WITH A NUMBER. IN THE END, YOUR **STACK of PLATES** WAS YOUR **DRINK TAB**: EACH **NUMBER** CORRESPONDED TO **DRINK PRICE** (popular in 1800s).

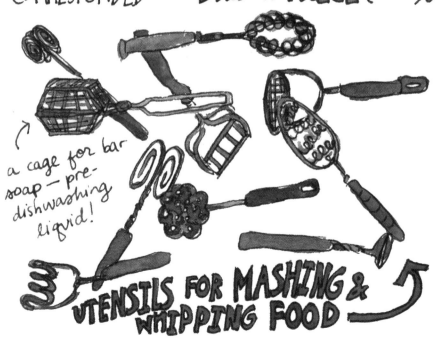

a cage for bar soap — pre-dishwashing liquid!

UTENSILS FOR MASHING & WHIPPING FOOD

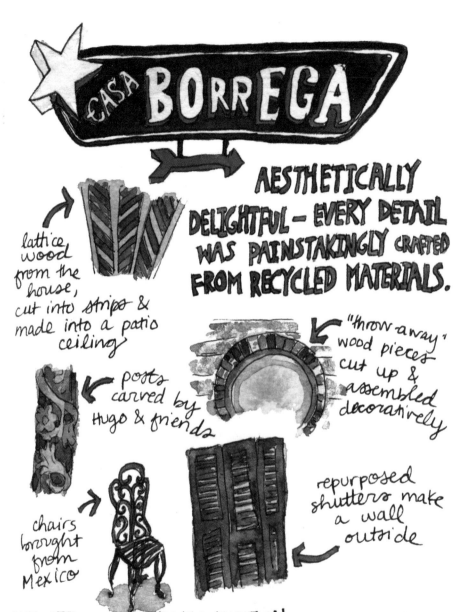

CASA BORREGA

AESTHETICALLY DELIGHTFUL — EVERY DETAIL WAS PAINSTAKINGLY CRAFTED FROM RECYCLED MATERIALS.

lattice wood from the house, cut into strips & made into a patio ceiling

"throw away" wood pieces cut up & assembled decoratively

posts carved by Hugo & friends

repurposed shutters make a wall outside

chairs brought from Mexico

HOUSED IN A GREEK REVIVAL DOUBLE-SHOTGUN FROM 1891. IN 2008, IT WAS IN BAD SHAPE: "NOTHING WAS HERE. IT WAS A BOX. PEOPLE COME NOW & THINK IT WAS LIKE THIS FOREVER — BUT IT WASN'T."

"MY GRANDMA'S HOUSE IS NOW A FEMA HOUSE — VINTERELLA'S GROCERY IS GONE — SO IS MONROE BAKERY, MONROE PHARMACY, MORTILLARO'S SNOBALL STAND... AS THEY SAY HERE IN NEW ORLEANS, "AIN'T DERE NO MORE."

lots of stories of Hollygrove in the 1960s & 70s

Julian, remembering HOLLY GROVE

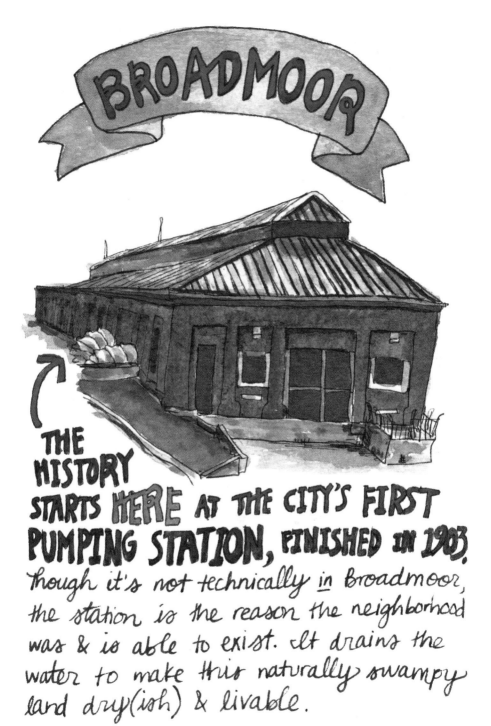

BROADMOOR

THE HISTORY STARTS HERE AT THE CITY'S FIRST PUMPING STATION, FINISHED IN 1903, though it's not technically _in_ Broadmoor, the station is the reason the neighborhood was & is able to exist. It drains the water to make this naturally swampy land dry(ish) & livable.

PLAYSPOT PARK

THE FIRST SPOT THE NEIGHBORHOOD COALESCED AROUND OVER **100 YEARS AGO**

THE 3 "Y-STREETS" ANCHOR THE NEIGHBORHOOD

evidenced in BIA's **logo** →

EL PAVO REAL ✗

FOUNTAINBLEAU DRIVE

S. BROAD AVE

NAPOLEON AVE

ROSA F ✗ **KELLER LIBRARY**

(THE LOWEST POINT IN NEW ORLEANS)

✗ BROADMOOR ARTS & WELLNESS CENTER

✗ ANDREW H WILSON SCHOOL

BROADMOOR PRIDES ITSELF ON ACTIVISM.
THERE'S A LONG TRADITION OF PARTICIPATION
IN COMMUNITY EVENTS. THIS IS BEST
EMBODIED IN THE BROADMOOR IMPROVEMENT
ASSOCIATION (BIA) WHICH NOW OPERATES
OUT OF THE ARTS & WELLNESS CENTER
(FORMERLY ST MATTHIAS CATHOLIC SCHOOL) OPENED
IN 2015.

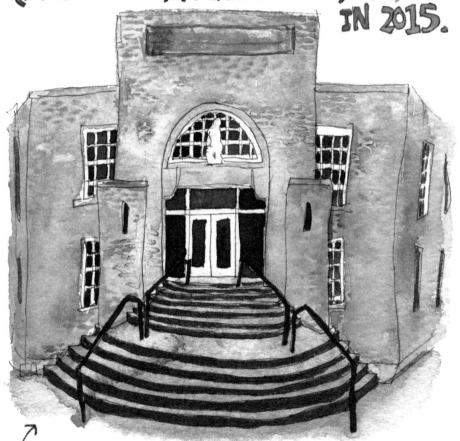

PROGRAMMING FOR ALL INTERESTS & AGES

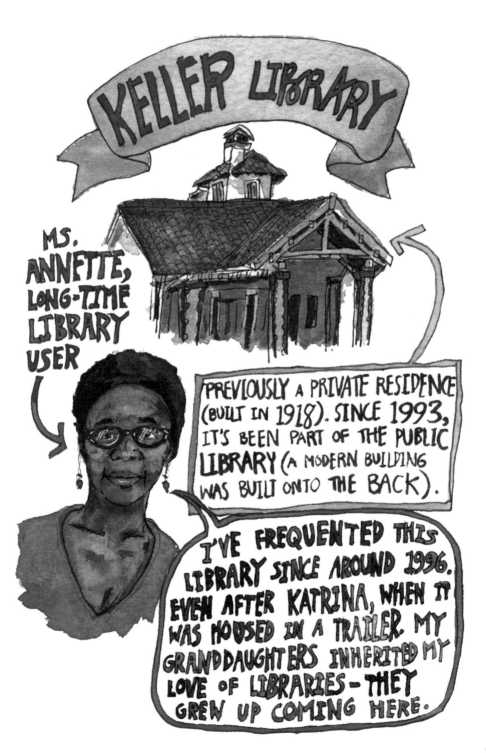

the infamous GREEN DOT

AFTER KATRINA: CITY OFFICIALS, UNSURE RESIDENTS WOULD RETURN, DESIGNATED SEVERELY DAMAGED AREAS WITH A GREEN DOT ON A MAP, INDICATING THOSE AREAS WOULD BE RAZED & MADE INTO PUBLIC PARKS. BROADMOOR WAS "GREEN-DOTTED" AND TOLD THAT UNLESS THEY GET 51% OF RESIDENTS TO RETURN, THEY'LL BE FLATTENED. BROADMOOR RALLIED TOGETHER & CAME BACK STRONGER THAN EVER.

ROSA KELLER LIBRARY

ANDREW H. WILSON SCHOOL ARTS & WELLNESS CENTER

THE RAISED BASEMENT

is classic Broadmoor architecture (1 in 5 houses have it) & distinct to New Orleans.

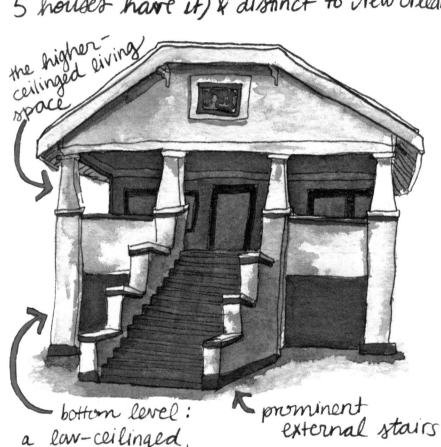

the higher-ceilinged living space

bottom level: a low-ceilinged, above-ground basement

prominent external stairs

AN ARCHITECTURAL SOLUTION TO THE CITY'S ALL-TOO-FAMILIAR FLOODING PROBLEM, MOST CONCENTRATED IN BROAD-MOOR.

MS LYNN HAS LIVED IN BROADMOOR SINCE 1970 (BORN ON "THE OTHER SIDE OF WASHINGTON," HERS WAS ONE OF THE FIRST BLACK FAMILIES TO CROSS WASHINGTON STREET TO THE BROADMOOR SIDE) AND WENT TO WILSON SCHOOL. SHE HAD A HARROWING KATRINA EXPERIENCE AND SAYS THE STORM CHANGED HER LIFE:

WE STAYED IN OUR TWO-STORY, RAISED-BASEMENT BROADMOOR HOME DURING KATRINA. WE THOUGHT WE'D BE OKAY — WE WEREN'T. A TREE HIT US ABOUT 6AM & THE WALL FELL IN. WE WENT TO OUR NEIGHBOR'S HOUSE — THEN THE LEVEE BROKE AND THE WATER CAME. ALL WAS UNDERWATER — IT FELT LIKE WE WERE IN A SWAMP. AFTER 5 DAYS WE WERE RESCUED BY HELICOPTER. WE LIVED IN VEGAS FOR A YEAR & A HALF THEN CAME BACK — THIS IS HOME.

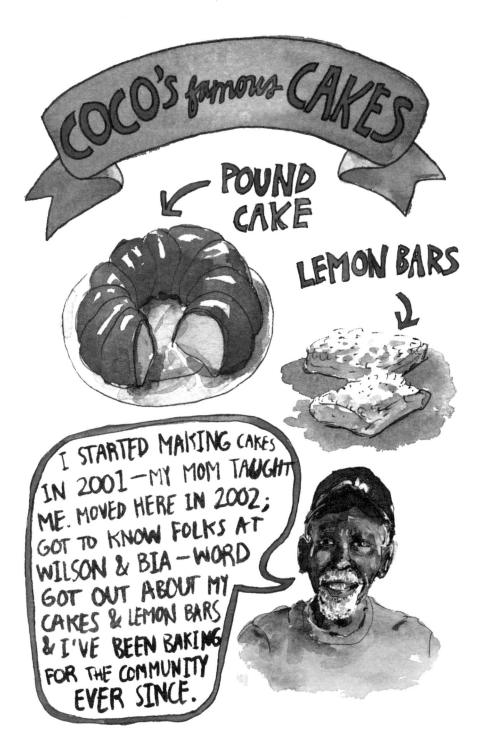

COCO'S famous CAKES

POUND CAKE

LEMON BARS

I STARTED MAKING CAKES IN 2001—MY MOM TAUGHT ME. MOVED HERE IN 2002; GOT TO KNOW FOLKS AT WILSON & BIA—WORD GOT OUT ABOUT MY CAKES & LEMON BARS & I'VE BEEN BAKING FOR THE COMMUNITY EVER SINCE.

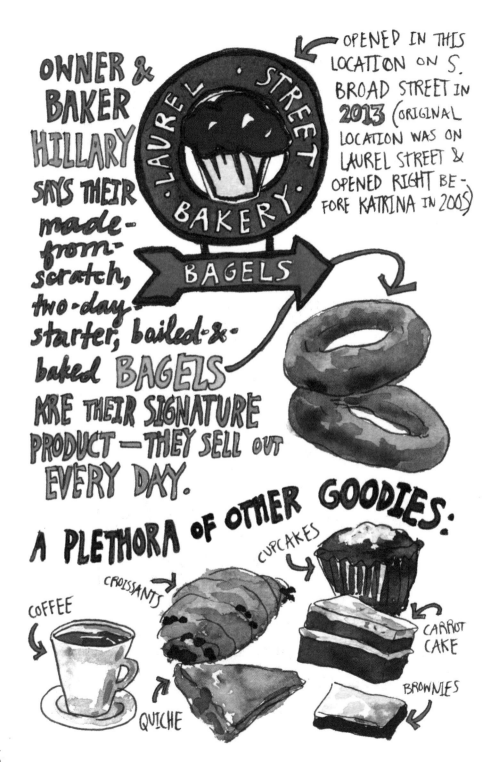

OWNER & BAKER HILLARY SAYS THEIR made-from-scratch, two-day-starter, boiled-&-baked BAGELS ARE THEIR SIGNATURE PRODUCT — THEY SELL OUT EVERY DAY.

LAUREL · STREET · BAKERY ·

BAGELS

OPENED IN THIS LOCATION ON S. BROAD STREET IN 2013 (ORIGINAL LOCATION WAS ON LAUREL STREET & OPENED RIGHT BEFORE KATRINA IN 2005)

A PLETHORA OF OTHER GOODIES:

COFFEE

CROISSANTS

QUICHE

CUPCAKES

CARROT CAKE

BROWNIES

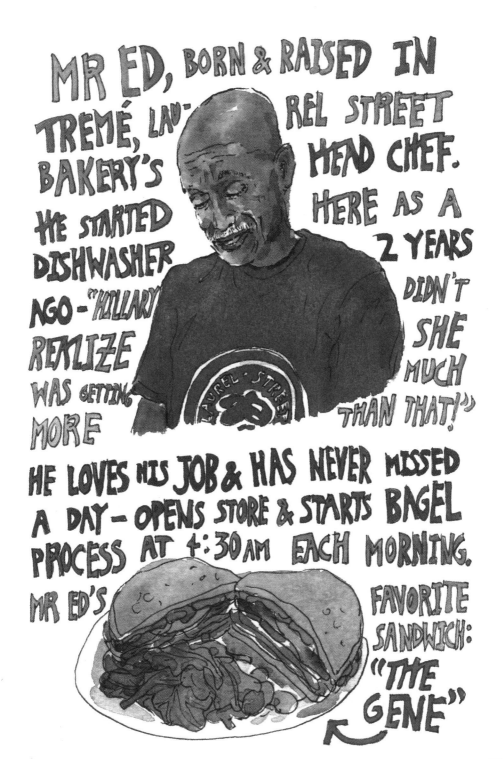

MR ED, BORN & RAISED IN TREMÉ, LAU-REL STREET BAKERY'S HEAD CHEF. HE STARTED HERE AS A DISHWASHER 2 YEARS AGO - "HILLARY DIDN'T REALIZE SHE WAS GETTING MUCH MORE THAN THAT!"

HE LOVES HIS JOB & HAS NEVER MISSED A DAY - OPENS STORE & STARTS BAGEL PROCESS AT 4:30 AM EACH MORNING. MR ED'S FAVORITE SANDWICH: "THE GENE"

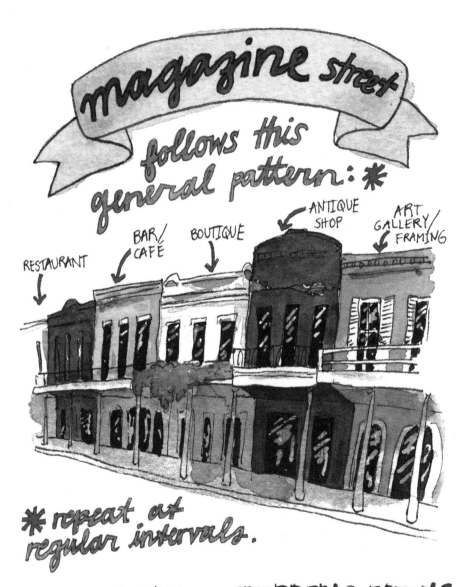

magazine street

follows this general pattern: *

RESTAURANT

BAR/CAFÉ

BOUTIQUE

ANTIQUE SHOP

ART GALLERY/FRAMING

* repeat at regular intervals.

FOR STROLLING, SHOPPING, EATING & DRINKING. A (SEEMINGLY ENDLESS) COMMERCIAL STREET FOR LEISURE & SHOPPING.

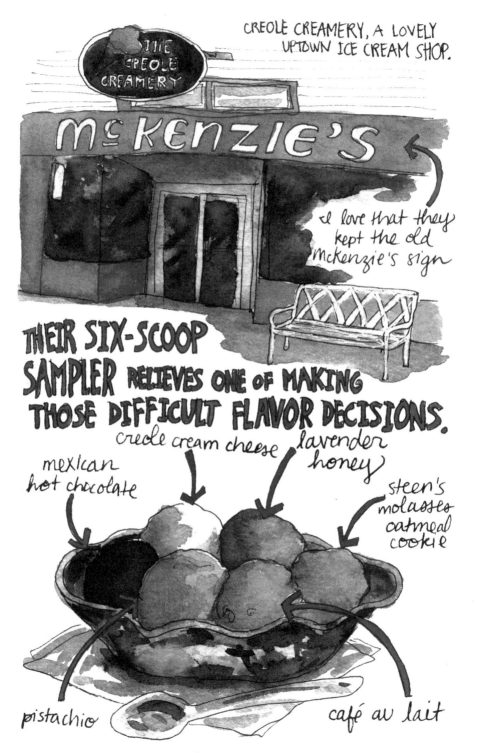

CREOLE CREAMERY, A LOVELY UPTOWN ICE CREAM SHOP.

THE CREOLE CREAMERY

McKENZIE'S

I love that they kept the old mckenzie's sign

THEIR SIX-SCOOP SAMPLER RELIEVES ONE OF MAKING THOSE DIFFICULT FLAVOR DECISIONS.

creole cream cheese

lavender honey

mexican hot chocolate

steen's molasses oatmeal cookie

pistachio

café au lait

URBAN roots

an oasis of green on Tchoupitoulas street.
great plant selection — plus a little basket of
free, fresh eggs from their
resident
chickens!

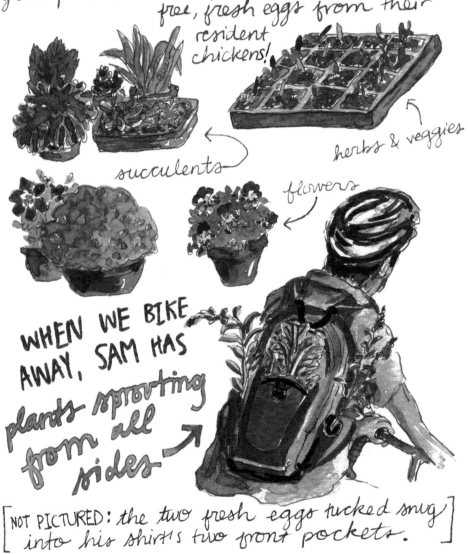

herbs & veggies

succulents

flowers

WHEN WE BIKE
AWAY, SAM HAS
plants sprouting
from all
sides →

[NOT PICTURED: the two fresh eggs tucked snug]
[into his shirt's two front pockets.]

SOUTHERN LIVE OAKS

(SCIENTIFIC NAME: QUERCUS VIRGINIANA)

form shady canopies over uptown streets

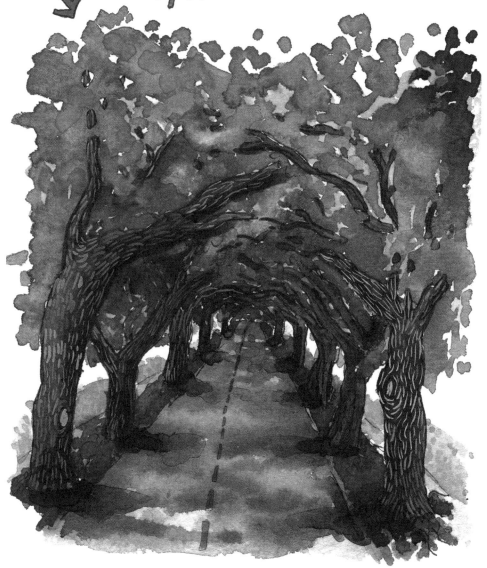

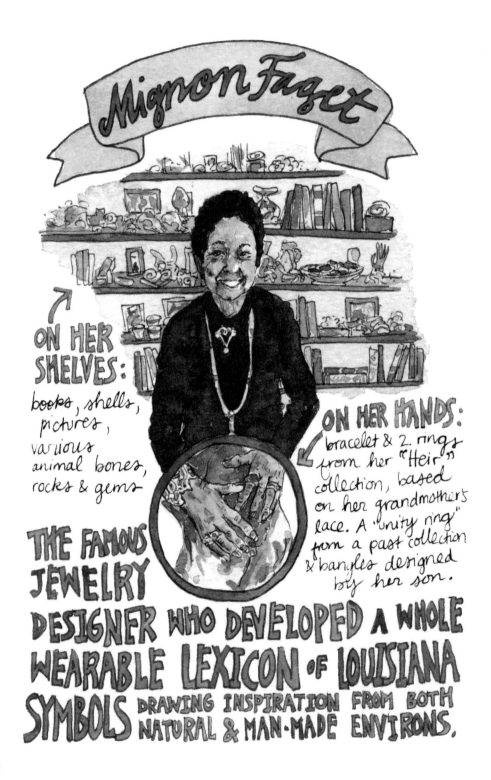

Mignon Faget

ON HER SHELVES:
books, shells, pictures, various animal bones, rocks & gems

ON HER HANDS: bracelet & 2 rings from her "Heir" collection, based on her grandmother's lace. A "unity ring" from a past collection & bangles designed by her son.

THE FAMOUS JEWELRY DESIGNER WHO DEVELOPED A WHOLE WEARABLE LEXICON OF LOUISIANA SYMBOLS DRAWING INSPIRATION FROM BOTH NATURAL & MAN-MADE ENVIRONS.

the Garden District

is renowned for its grandeur: extravagent, enormous houses of architectural acclaim, such as

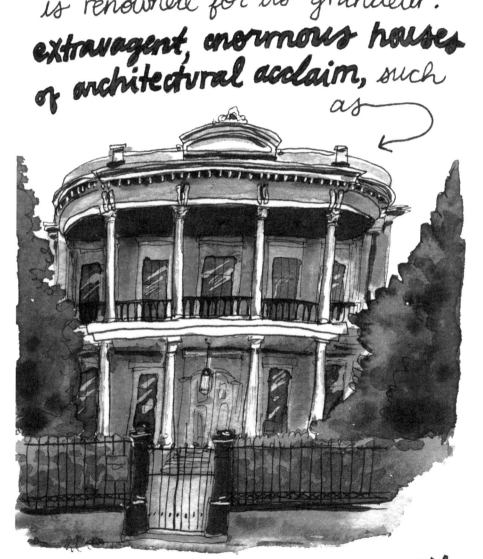

THE WALTER GRINNAN ROBINSON HOUSE, built 1859 in the Italianate style.

along St Charles Avenue, YOU'LL FIND THE TOP OF THE EIFFEL TOWER. no, really: THIS WAS THE RESTAURANT ATOP THE EIFFEL TOWER IN PARIS FROM 1937 UNTIL 1981 WHEN IT

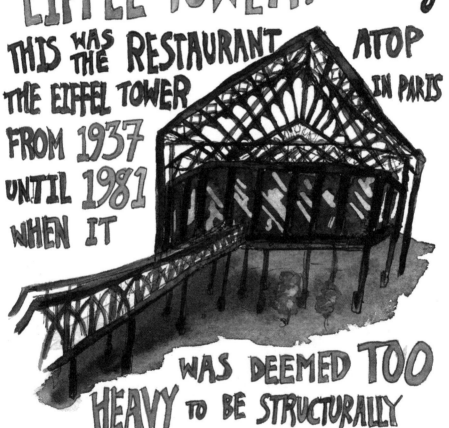

WAS DEEMED TOO HEAVY TO BE STRUCTURALLY SAFE. SO IT WAS SHIPPED, PIECE BY PIECE (all 11,000 of them) TO A RESTAURATEUR IN NEW ORLEANS. Today, it's home to "THE EIFFEL SOCIETY."

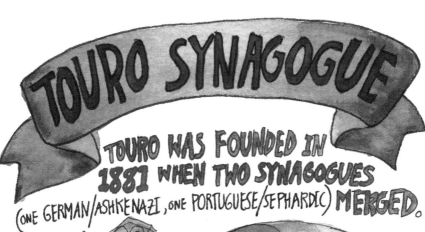

TOURO SYNAGOGUE

TOURO WAS FOUNDED IN 1881 WHEN TWO SYNAGOGUES (ONE GERMAN/ASHKENAZI, ONE PORTUGUESE/SEPHARDIC) MERGED.

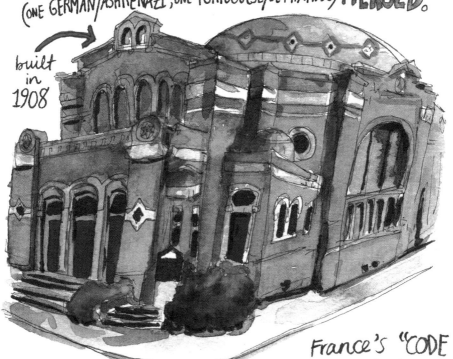

built in 1908

France's "CODE NOIR" (1724) forbade Jews from entering Louisiana's then-French territory, but this wasn't strictly enforced. When Louisiana became part of America in 1803, Jews in New Orleans were freer to worship & develop businesses (THOUGH IN GENERAL, THEIR WELCOME IN THE CITY HAS BEEN ERRATIC OVER THE YEARS).

225

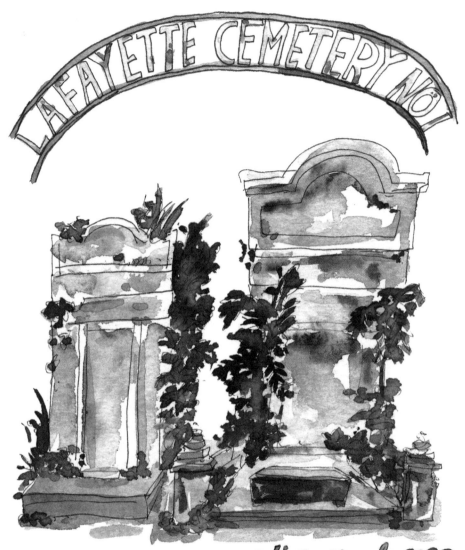

grasses sprouting from
stone tombs beneath
a canopy of magnolias

COMMANDER'S PALACE RESTAURANT

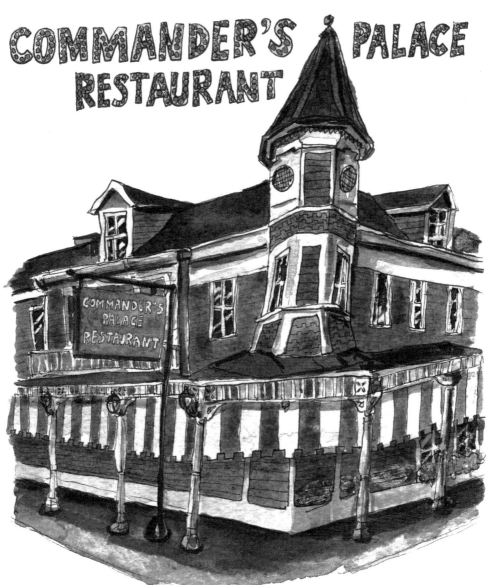

THAT **TURQUOISE** ("Commander's blue") — THOSE STRIPED CANOPIES — THE TURRET — there's plenty of whimsy at this classic New Orleans landmark. (ALSO NOTE-WORTHY: THE 25¢ MARTINIS YOU CAN GET WITH LUNCH. <u>**25¢!**</u>)

MR RUPPERT KOHLMAIER IS A REVERED CABINETMAKER. HE LEARNED THE CRAFT FROM HIS FATHER, WHO CAME TO NEW ORLEANS FROM GERMANY IN THE 1920s. FIND HIM WORKING AWAY IN HIS WOOD-WORKING STUDIO ON HARMONY STREET.

inlay is his specialty

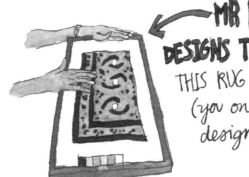

MR KOHLMAIER ALSO DESIGNS TEXTILES — HE PAINTED THIS RUG DESIGN IN **1967.** (you only make ¼ of the design — the rest is mirrored).

A CHAIR MR KOHL-WAITING REUP- OUTSIDE MAIER'S SHOP, TO BE HOLSTERED.

"THIS EGYPTIAN REVIVAL STYLE BUILDING, CONSTRUCTED IN 1836, WAS THE COURTHOUSE FOR THE CITY OF LAFAYETTE (A SEPARATE CITY UNTIL 1852).

SEANN HALLIGAN's *great grandfather* FOUNDED THE CORNER CLUB IN 1918; HIS *grandfather* (JOHN "BUBBY" GALLAGHER) REVITALISED IT IN 1947 (IT HAD DIS-BANDED FOR A FEW YEARS DURING THE GREAT DEPRESSION & WWII). SEANN IS THE 4TH GENERATION (HIS MOTHER, THE 3RD GENERATION, COULDN'T BE ACTIVE IN THE ALL-MEN'S SOCIAL GROUP, OF COURSE) & THE CLUB's CURRENT PRESIDENT.

PETE'S OUT IN THE COLD

or just "PETE'S." neighborhood dive bar.

OUT IN THE COLD
EST. 1931

CHEAP DRINKS, NO FRILLS AT THIS IRISH CHANNEL WATERING HOLE.

nighttime POBOYS at PARASOL'S

ROAST BEEF, the Parasol's classic

the MANY essential condiments: ketchup, various hot sauces, vinegar, salt & pepper

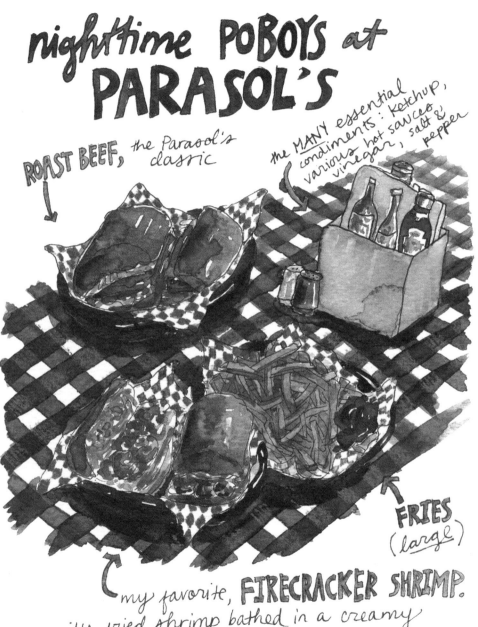

FRIES (large)

my favorite, FIRECRACKER SHRIMP. it's fried shrimp bathed in a creamy spicy sauce

½ CORNER STORE, ½ PRIVATE RESIDENCE

the corner store is no longer in business, but what a fantastic prototype!

THINGS RECEIVED IN ABUNDANCE
at the
ST PATRICK'S DAY PARADE:

cabbages

and kisses

PLASTIC FLOWERS, POTATOES, BEADS, CARROTS—

all well & good, but nothing holds a candle to the winning combination that is **CABBAGES & KISSES**.

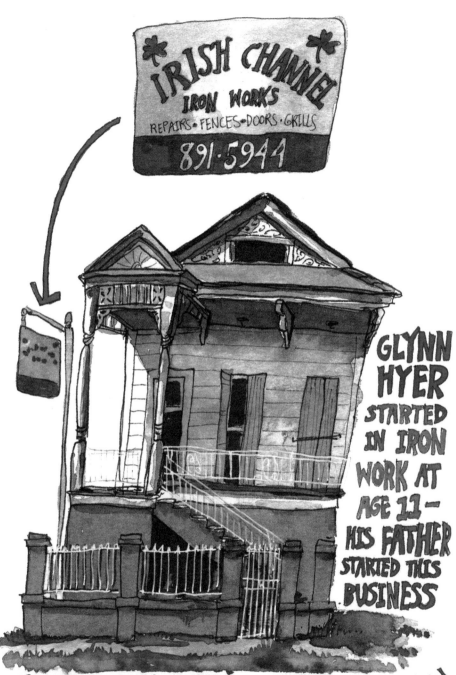

IRISH CHANNEL
IRON WORKS
REPAIRS · FENCES · DOORS · GRILLS
891·5944

GLYNN HYER STARTED IN IRON WORK AT AGE 11 — HIS FATHER STARTED THIS BUSINESS

IN 1971. TODAY, GLYNN'S SON (ALSO NAMED GLYNN) IS LEARNING THE ROPES: A 3RD-GENERATION BUSINESS.

irish channel iron works

"EVERY JOB WE DO IS CUSTOM—MOSTLY FIXING HISTORIC IRONWORK IN THE IRISH CHANNEL, GARDEN DISTRICT, FRENCH QUARTER, MARIGNY, MID CITY—ANYWHERE THAT NEEDS US. THE RULE IS: WE DON'T WORK ON ANYTHING BUILT AFTER THE 1960s."

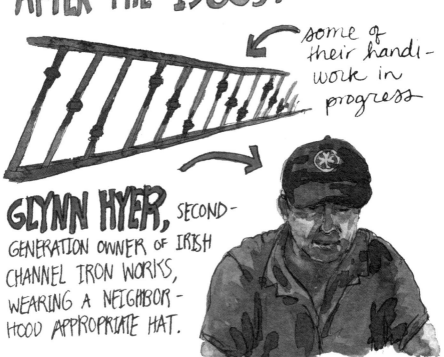

some of their handi-work in progress

GLYNN HYER, SECOND-GENERATION OWNER OF IRISH CHANNEL IRON WORKS, WEARING A NEIGHBOR-HOOD APPROPRIATE HAT.

BREWERIES USED TO LINE THE RIVER (ALONG TCHOUPITOULAS STREET) IN LARGE NUMBERS.

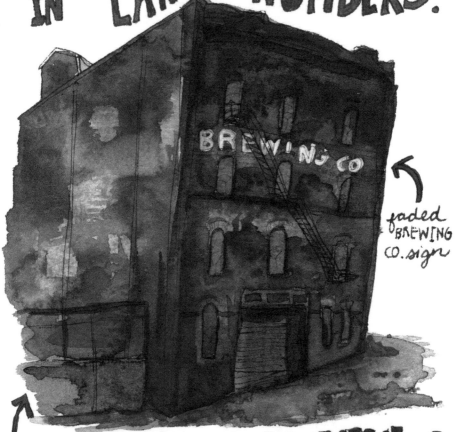

faded BREWING CO. sign

THIS BUILDING IS THE LAST VESTIGE OF THE NEW ORLEANS BREWING COMPANY COMPLEX WHICH PROSPERED FROM 1890 TO 1949

local breweries are cropping up once again, harkening back to the city's former status as "BREWING CAPITAL OF THE SOUTH" (LATE 19TH TO MID 20TH CENTURY)

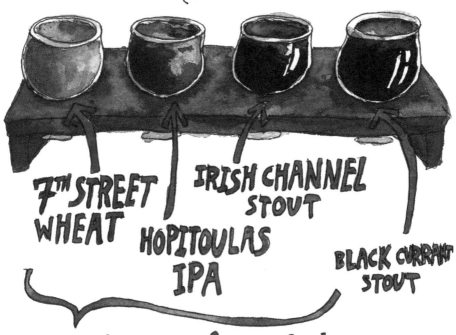

7TH STREET WHEAT

HOPITOULAS IPA

IRISH CHANNEL STOUT

BLACK CURRANT STOUT

flight of local brews at the NOLA BREWING CO. TAP ROOM

THESE TWO SPECTACULAR CHURCHES
are next-door-neighbors

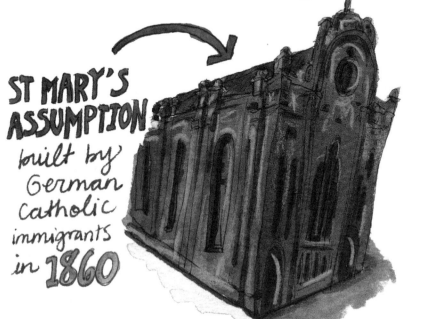

ST MARY'S ASSUMPTION
built by German Catholic immigrants in 1860

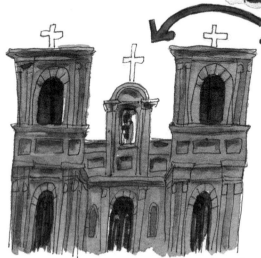

ST ALPHONSUS
built by Irish Catholic immigrants in the 1850s

find them along Constance Street

MONUMENT TO VERA

on the corner of Magazine & Jackson Ave

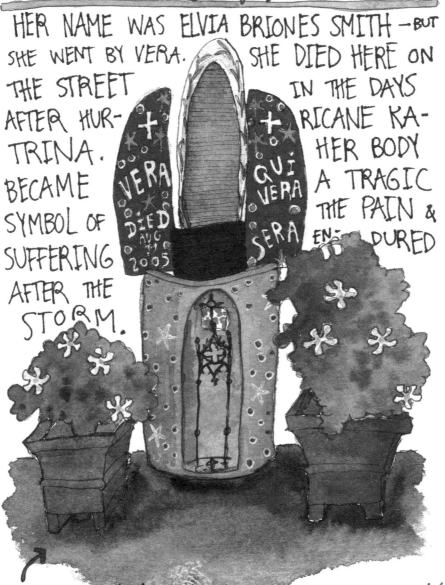

HER NAME WAS ELVIA BRIONES SMITH — BUT SHE WENT BY VERA. SHE DIED HERE ON THE STREET IN THE DAYS AFTER HUR- RICANE KA- TRINA. HER BODY BECAME A TRAGIC SYMBOL OF THE PAIN & SUFFERING EN- DURED AFTER THE STORM.

VERA DIED AUG 29 2005

QUI VERA SERA

it was painted by local artist Simon Hardeveld

so close, yet so far:

algiers point

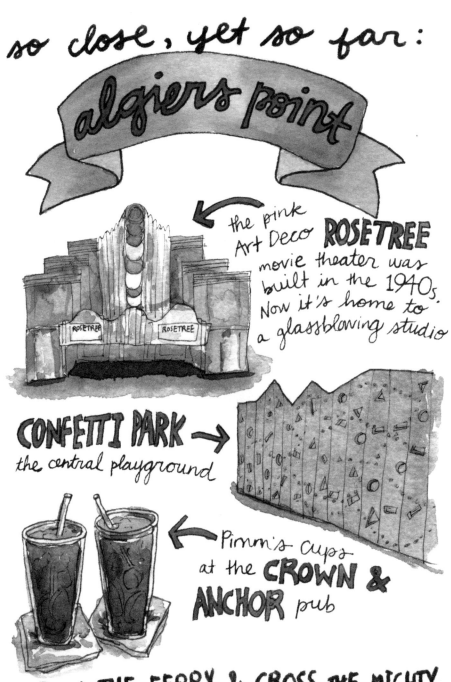

← the pink Art Deco **ROSETREE** movie theater was built in the 1940s. Now it's home to a glassblowing studio

CONFETTI PARK →
the central playground

← Pimm's cups at the **CROWN & ANCHOR** pub

HOP ON THE FERRY & CROSS THE MIGHTY MISSISSIPPI TO THIS SMALL ALTERNATE UNI-VERSE

"THERE'S A NEW BREED IN TOWN: *THE YUPPIE.* ME, I'M ALMOST 80 YEARS OLD."

he thumps his chest with his fist —

"MADE OF STEEL."

WAYNE, born & raised in Algiers Point, discussing neighborhood changes at THE OLD POINT BAR.

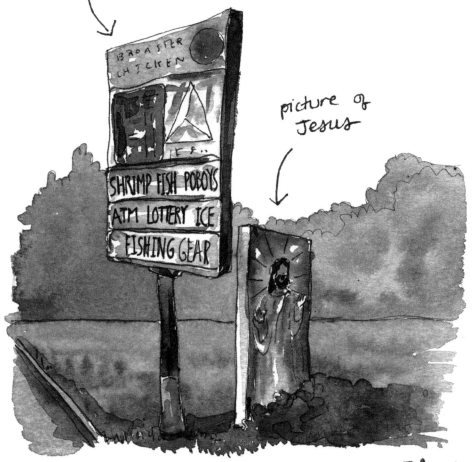

A NETWORK

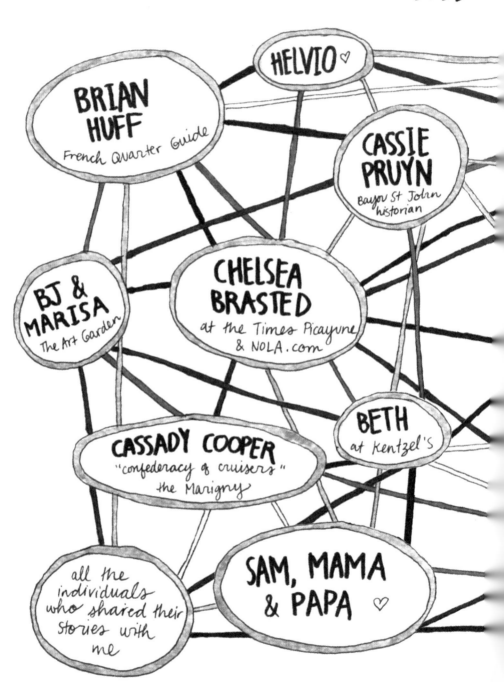

HELVIO ♡

BRIAN HUFF
French Quarter Guide

CASSIE PRUYN
Bayou St John historian

BJ & MARISA
The Art Garden

CHELSEA BRASTED
at the Times Picayune & NOLA.com

BETH
at Kentzel's

CASSADY COOPER
"confederacy of cruisers"
the Marigny

all the individuals who shared their stories with me

SAM, MAMA & PAPA ♡

OF THANKS

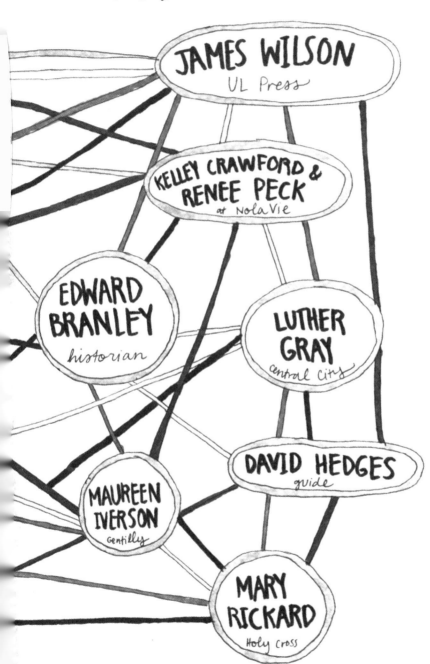

JAMES WILSON
UL Press

KELLEY CRAWFORD &
RENEE PECK
at NolaVie

EDWARD
BRANLEY
historian

LUTHER
GRAY
central city

DAVID HEDGES
guide

MAUREEN
IVERSON
Gentilly

MARY
RICKARD
Holy Cross

247

ABOUT THE ARTIST

Emma Fick was born in Covington, Louisiana, in 1991. In addition to traveling and working on the "Snippets of" series, she shows her art in and around New Orleans. This is her second book.

www.emmafick.com